ON THE HOLY ICONS

ST VLADIMIR'S SEMINARY PRESS
Popular Patristics Series
Number 6

The Popular Patristics Series published by St Vladimir's Seminary Press provides readable and accurate translations of a wide range of early Christian literature to a wide audience—students of Christian history to lay Christians reading for spiritual benefit. Recognized scholars in their fields provide short but comprehensive and clear introductions to the material. The texts include classics of Christian literature, thematic volumes, collections of homilies, letters on spiritual counsel, and poetical works from a variety of geographical contexts and historical backgrounds. The mission of the series is to mine the riches of the early Church and to make these treasures available to all.

Series Editor
BOGDAN BUCUR

Associate Editor
IGNATIUS GREEN

* * *

Series Editor
1999–2020
JOHN BEHR

ON THE HOLY ICONS

St Theodore the Studite

Translated by
CATHARINE P. ROTH

ST VLADIMIR'S SEMINARY PRESS
CRESTWOOD, NEW YORK

LIBRARY OF CONGRESS CATALOGING-IN-PUBLICATION DATA

Theodore, Studite, Saint 759-826
 St. Theodore the Studite on the holy icons.
 Translated from the original Greek.
 1. Icons—Cult—Early works to 1800. I. Roth, Catharine. II. Title.
BX323.T44 1981 246'.53 81-18319
ISBN-13: 978-0-913836-76-7 AACR2
ISBN-10: 0-913836-76-1

ON THE HOLY ICONS

Translation Copyright © 1981 by
ST VLADIMIR'S SEMINARY PRESS
575 Scarsdale Road, Crestwood, NY 10707
www.svspress.com
1-800-204-2665

ISBN 978-0-913836-76-7
ISSN 1555-5755

PRINTED IN THE UNITED STATES OF AMERICA

Table of Contents

Introduction

The years before and after 800 A.D. found the Christian Roman Empire hard-pressed by new forces on all sides. The followers of Islam had already diminished Roman territory in the east, and now ruled the three apostolic patriarchates of Jerusalem, Alexandria, and Antioch. The pagan Bulgarians were a continual threat on the north. In the west, the consolidation of Frankish power, symbolized by Charlemagne's coronation as a new emperor in Old Rome, destroyed the theoretical unity of the political empire and foreshadowed the division of the spiritual world. These changes were reflected in the iconoclastic controversy, which involved not only the role of images in worship but also the relation between religious and secular authority.[1]

In these controversies St. Theodore the Studite was engaged throughout his life. He was born in Constantinople in 759, under the reign of Constantine V, the second iconoclast emperor. His education prepared him to follow his father into the imperial bureaucracy; but instead, under the influence of his mother Theoctista and her brother Plato, he retired with his whole family into monastic life. As abbot of the monastery of Saccudion in Bithynia, Plato received Theodore as a monk, and later resigned the abbacy in favor of his nephew. The two shared spiritual authority over their monks for eighteen years, first at

[1]See the selected bibliography for further information on the iconoclastic crisis in its historical and theological aspects.

Saccudion and then at the monastery of Studios in Constantinople.

Theodore and his brethren endured three periods of exile for their defense of orthodox Christian faith and morals. The first and second exiles were provoked by Theodore's opposition to the divorce and remarriage of the emperor Constantine VI. The third time, Theodore was exiled by Leo V for defending the veneration of images. Theodore would not admit that an emperor could change the decisions of the Church either in regard to marriage or in regard to faith and worship. The next emperor, Michael II, recalled him from exile but did not allow him to reside in Constantinople. Theodore died in semi-exile on 11 November 826.

Perhaps Theodore's greatest contribution to the future of the Church was his work in reforming and organizing monastic life. He supported his brethren by his catechetical discourses when he was with them and by his letters when in exile. He wrote hymns for Church use, especially for the season of Lent. He and his monks are credited with introducing the minuscule hand which was used from then on for copying Greek books. In theology, Theodore's main effort was the defense of icons. The largest part of his published work may be found in volume 99 of Migne's *Patrologia Graeca.*

The Church has usually made explicit formulations of doctrine only when forced to do so by the pressures of controversy. For this reason, dogmatic decisions tend to be formed by opposition with the arguments of the adversaries. This is true not only of the early councils' teachings on trinitarian theology and on christology, but equally of the defense of icons. The arguments in favor of icons were developed in reaction to iconoclastic criticisms. The first round of the controversy, in the eighth century, brought out the basic objections to icon-veneration; these

in turn called forth an orthodox response, most prominently from St. John of Damascus. The second generation of iconoclasts, especially the emperor Constantine V and the council of 754, refined their arguments with a subtler appeal to christology. St. Theodore the Studite and his contemporaries turned the christological argument to the advantage of icon-veneration. In Theodore's works, we find both a review of the older arguments and a fuller treatment of the issues which had more recently become prominent.

The obvious starting point for an attack on icons was (and is) the second commandment, prohibiting graven images.[2] The iconoclasts related this prohibition to the invisibility and incomprehensibility of God, referring to the fact that Moses heard God's voice but saw no form.[3] They also claimed that the superiority of spirit to matter made it inappropriate to use material images in spiritual worship. Their disdain for matter suggests that they were influenced as much by pagan neoplatonism as by the Hebrew tradition. The orthodox answers to these criticisms were formulated by John of Damascus and inherited by Theodore.[4] In the Old Testament itself, they could cite instances in which God instructed men to fashion images, such as the cherubim adorning the ark and the bronze serpent which healed the snakebite victims.[5] Of course their chief argument was the fact of the incarnation. Although God in Himself could certainly not be portrayed, God incarnate was seen and could be shown in a picture. The only difficulty in the depiction would be the difficulty inherent in the incarnation itself.

[2]Ex. 20.4.

[3]Deut. 4.12.

[4]St. John of Damascus, *On the Divine Images,* trans. David Anderson (Crestwood: St. Vladimir's Seminary Press, 1980).

[5]Ex. 25.18; Num. 21.8.

One more problem raised by the iconoclasts was that of how an image is related to its original. The iconoclasts asserted that a true image must have the same essence as its original, like Christ and the Father.[6] If a person venerates a purported image, he is guilty, in their view, of worshipping as God a thing which is not God: that is, of idolatry. John of Damascus mentions that there are differences between the image and its prototype, but does not discuss the relationship in detail.[7] He distinguishes different kinds of images and different kinds of veneration. In particular, he distinguishes the absolute worship or adoration which is due to God alone from the relative veneration which may be offered to the saints, to holy objects and places, and to persons in authority over us. The saints are venerated because they have been deified by grace, and the grace remains to make their relics and images venerable also.[8]

Both parties to the controversy used the argument from tradition: that is, what the Church has done in the past must be right. However, neither the history of ecclesiastical art nor the testimony of the fathers provided unqualified support for one side or the other. Art in the early Church was often symbolic rather than properly figurative: for example, Christ represented as a lamb or the good shepherd.[9] Some patristic writings were critical of iconography; John, followed by Theodore, calls spurious a work of St. Epiphanius of Cyprus which forbids images.[10]

In the first phase of the controversy, the orthodox were more successful than the iconoclasts in justifying

[6]Compare 2 Cor. 4.4; Col. 1.15.

[7]*On the Divine Images* 3.16.

[8]*On the Divine Images* 1.14-19; 3.28-40.

[9]Ouspensky, *Theology of the Icon,* chapters 3 and 4.

[10]*On the Divine Images* 2.18; St. Theodore the Studite, *Refutations of the Iconoclasts* 2.49.

their position theologically. The second phase began when the emperor Constantine V (Copronymus) presented his iconoclastic treatise to the council which he called in 754. His main points were adopted by the council. They replied to the incarnational argument for icons by proposing a christological dilemma. In a portrait of Christ, either the divine nature is portrayed along with the human nature or it is not. Divinity cannot be portrayed. Either the divine nature is confused with the human nature, which is monophysitism; or else, if the human nature alone is portrayed, the two natures are separated, which is Nestorianism. The council of 754 also maintained the iconoclast position that a true image must be of the same essence (ὁμοούσιος) with its prototype. Consequently, they asserted that the only valid image of Christ would be the eucharistic gifts. A pictorial representation obviously would not have the same essence as its prototype.

In the first treatise of his work *On the Holy Icons* or *Refutations of the Iconoclasts,* St. Theodore the Studite repeats the arguments which he inherited from the preceding generation, and deals more thoroughly with the new objections raised by the iconoclastic council. He replies to their dilemma with his own dilemma.[11] If Christ cannot be portrayed, then either He lacks a genuine human nature (which is docetism) or His human nature is submerged in His divinity (which is monophysitism). The council of Chalcedon (451) had held that Christ was "in two natures without confusion, without change, without division, without separation." If Christ's human nature is not changed or confused with His divine nature, then He must be able to be portrayed like any human being. If His two natures are not separated, then the one portrayed must be the incarnate God, even though the divine nature

[11]*Refutations of the Iconoclasts* 1.2-4.

itself cannot be portrayed. Indeed, it is not a nature which
can be portrayed, whether divine or human, but a hypos-
tasis. According to orthodox teaching, the Logos assumed
human nature in general, not a human hypostasis (in
other words, there is no man Jesus apart from the in-
carnate God).[12] Therefore Christ's human nature cannot
be portrayed as nature, but only as it occurs in the hypos-
tasis which combines the two natures. And in this hypos-
tasis Christ's humanity has the properties of an individual
man, including a particular appearance which was seen
and can be portrayed.

In answer to the iconoclast understanding of the mean-
ing of an image, Theodore elaborates on the relation of
the image to its prototype.[13] The image belongs to the
Aristotelian category of relative things (πρός τι), and so
it directs the attention from itself to its prototype. The
image and the prototype differ in essence, but share the
same likeness and are called by the same name. Insofar
as the image is like its prototype, the prototype may be
venerated in the image. The nature of the image (wood,
paint, etc.) is not venerated, but only the likeness of the
prototype which appears in the image. The eucharistic
gifts, which alone are recognized as a true image of
Christ by the iconoclasts, are according to Theodore not
an image at all but the reality of Christ's body and blood.
He finds a closer analogy for the veneration of icons in
the veneration of other material objects. Even the icon-
oclasts honored the symbol of the cross, the book of the
gospels, and other sacred objects. Theodore accuses them
of inconsistency in refusing to venerate also the icons.

Theodore deals further with the correctness of ven-
erating icons in his second treatise, which is concerned

[12]Meyendorff, *Christ in Eastern Christian Thought*, p. 55; Peli-
kan, *The Christian Tradition* vol. 2, p. 117.

[13]*Refutations of the Iconoclasts* 1.8-12.

with two types of moderate iconoclasts. Some of them admitted that pictures could be made of Christ and the saints, but not that the images could be venerated. Others admitted that Christ could be portrayed as He appeared before His passion, but not as He was after His resurrection. Theodore argues that Christ can be the prototype of an image because of His humanity.[14] He quotes St. Basil the Great, who says, "The honor given to the image passes over to the prototype."[15] In saying this, Basil was using the emperor's portrait as an analogy for Christ as the image of the Father, to suggest how Christ can share the worship due to God. Theodore has thus borrowed an argument from trinitarian theology for the doctrine of icons; he admits this, and points out that his use of the comparison is closer than Basil's.[16] The fact that Basil uses the word "honor" (τιμή) leads Theodore to discuss at some length the relation of veneration with honor, and then with holiness.[17] He argues that anything which is honorable, holy, or august must be in some degree venerable. If this seems to be a quibble about words, there is a real question, what kind of honor we may properly give to images, to the cross, etc. The moderate iconoclasts would allow pictures to be placed high on the walls of churches, to be honored for their educational value, but not to be touched or kissed. This view has frequently been expressed by western Christian writers from St. Gregory the Great to the present.[18] Theodore, however, finds it inconsistent to kiss the cross and the gospel book but to gaze at the icons only from a distance.

Later in the second treatise, Theodore takes up the

[14]*Refutations of the Iconoclasts* 2.4.

[15]*On the Holy Spirit* 18.45.

[16]*Refutations of the Iconoclasts* 2.25.

[17]*Refutations of the Iconoclasts* 2.12-40.

[18]Ouspensky, *Theology of the Icon,* p. 133-4.

arguments of those who would allow pictures of Christ only before his passion.[19] He points out that even after the resurrection Christ appeared as a man, ate fish, and was touched by St. Thomas. Even before the passion, he walked on water and was transfigured. So there is no biblical justification for saying that Christ was able to be portrayed at one time but not at another.

Theodore's third treatise reviews the whole case for icon-veneration, in the form of a series of syllogisms classified under four headings. Part A deals with the possibility of portraying Christ in the body, using primarily arguments from christology, with support from biblical texts, grammar, geometry, and philosophy. The essential point remains that because Christ has a genuine human nature He must be circumscribed and therefore portrayable like any human being. In part B, Theodore summarizes his argument on the meaning of an artificial image, which shares the likeness but not the essence of its prototype. Hence Christ's likeness can be seen in His image, or the likeness of the image in Him. Part C expounds the consequence, that Christ's likeness which is venerable in Him Himself is also venerable in the image, since it is the same likeness. The identity of likeness and veneration is further discussed in part D.

The iconoclastic controversy, like other theological controversies, required precise distinctions in terminology. These distinctions must be maintained by the translator. Theodore borrowed some technical terms from the christological controversies: for example, οὐσία (essence), φύσις (nature), ὑπόστασις (hypostasis), πρόσωπον (person). Even "theology" has a technical sense, referring to the doctrine of God in Himself, opposed to "economy" or "dispensation," which refers to God's dealings with

[19]*Refutations of the Iconoclasts* 2.41-47.

the world. In orthodox doctrine, God has one essence, one nature, three hypostases, three persons. Christ and the Spirit have the same essence as the Father (ὁμο-ούσιοι). Christ has two natures in one hypostasis and one person. In contrast, the monophysites (non-Chalcedonians) say one nature; while the Nestorians (non-Ephesians) say two hypostases but one person. On the subject of images, the iconoclasts wanted an image to have the same essence with its prototype; Theodore declares that the image differs in essence but bears the likeness of the hypostasis of its prototype.

In discussing icons, Theodore uses a series of approximate synonyms without making technical distinctions among them: εἰκὼν (image or icon), ὁμοίωμα (likeness), εἶδος (appearance), τύπος (symbol, representation), μορφὴ (form or shape), σχῆμα (figure), χαρακτήρ (imprint, character), etc. It has not been possible to achieve complete consistency in translating these words, because of the various ranges of Greek and English usage. In particular, εἰκὼν may vary from "image" in an abstract sense to "image" in a concrete sense (a material picture) to "icon" in the technical ecclesiastical sense. For the response to images, Theodore, like John of Damascus, does make a careful distinction (which was missed by the contemporary Latins, apparently because of an inadequate translation).[20] Worship properly speaking, or adoration (λατρεία) is due to God alone; veneration in general (προσκύνησις) may be offered to respected individuals, relics of saints, or other holy objects including the icons. Both words occur in biblical references, where this translation has tried to represent them consistently. In other cases also the exigency of the argument or the use of the Septuagint text has required a departure

[20]Ouspensky, *Theology of the Icon,* p. 170.

from the Revised Standard Version, which has ordinarily
been used for biblical quotations. In general the transla-
tion has been made from the text of Sirmond as published
in Migne, *Patrologia Graeca*, vol. 99, col. 328-436 (*Anti-
rhetici adversus iconomachos*); evident misprints have been
corrected where necessary. Subtitles have been added by
the translator.

To many modern Christians the question of icon-
veneration may seem a marginal issue in theology. To St.
Theodore, it was clear that iconoclasm is a serious error,
which alienates its followers from God as much as any
other heresy.[21] That is to say, an iconoclast effectively
denies God's incarnation which alone makes human sal-
vation possible. If Christ could not be portrayed both
before and after His resurrection, then He was not truly
man, humanity was not truly united with God, and no
human beings could expect to become "partakers of the
divine nature."[22] A modern namesake of St. Theodore's
provides striking parallels to this attack on iconoclasm.
Theodore Roszak criticizes western Christianity for limit-
ing the self-revelation of God to the spoken word (as
in Judaism)[23] and the eucharistic gifts (as in iconoclasm).[24]
Because God was not seen in any other material objects,
the created world was emptied of God. The material
world was understood as mere matter. Where there is no
"sacramental consciousness," there is no restraint on scien-
tific analysis and technological exploitation of the cosmos.[25]
The desacralized world has become the object of the first
true idolatry for those who have lost all awareness of

[21]*Refutations of the Iconoclasts* 1.20.

[22]2 Pet. 1.4.

[23]Theodore Roszak, *Where the Wasteland Ends* (Garden City:
Anchor Books, 1973), p. 103.

[24]Roszak, p. 112.

[25]Roszak, p. 125.

God (pagans always believed that the gods were more than their images).[26] So a good case can be made that the spiritual sickness of the West, which has spread to so much of the world, had its origin not in Christianity *per se* but in a heretical misunderstanding of the Christian doctrine of icons.

The translator wishes to thank for their assistance Fr. John Meyendorff, Fr. James Karagas, Deacon Basil Luschnig, Professor Cecilia Luschnig, the librarians of Incarnate Word College, and, above all, my husband Fr. Gregory Roth.

<div style="text-align: right">

—Catharine P. Roth
San Antonio, Texas
October 1981

</div>

[26]Roszak, pp. 106, 125.

First Refutation of The Iconoclasts

"There is a time to speak" and not "to keep silent"[1] if one has any ability in speaking; since a certain heresy is threatening us, barking at the truth, and frightening unstable minds by its empty noise. For a speaker might perhaps accomplish these two things: he might reinforce his own understanding, by sorting out the component arguments concerning the matter at issue and putting them in order; and he might share his findings with others, if anyone were willing to listen. Therefore, inadequate as I am to both tasks, yet relying on the prayers and urgings of my fathers, I will try to show as well as possible how I understand the problem. "It is better," says the theologian, "to contribute what one can than to leave the whole task undone"; especially since I did not explain it sufficiently in the *Invective* which I wrote.[2] Now, however, I will set forth the argument by opposing our own teaching and that of the other side, so that by the juxtaposition, as in some kind of assay, the debased and adulterated currency of impiety may be cast out from the trustworthy and genuine coinage of the truth. "The Lord will give words to those who preach in a great host":[3] if indeed, unworthy as I am, I may quote the Psalmist as I begin my treatise.

[1] Eccl. 3.7.
[2] An unpublished work of St. Theodore.
[3] Ps. 67 (68).11.

1. We Christians, you know, O heretics, have one worship, and one veneration—I mean, for the Father, the Son, and the Holy Spirit—because that which is venerated is one in the nature of divinity, although those which are intellectually perceived are three in their hypostatic properties, according to our normal teaching.

THE ACCUSATION OF IDOLATRY

2. The heretics say, "Surely there is not just one veneration, if our piety is shown to have many objects of veneration by the erection of icons, a practice which by some wile of the devil has been transferred from pagan tradition, bringing the veneration of idols into the catholic church.[4] For every theologian agrees that the Godhead is entirely incomprehensible and uncircumscribable."

It is obvious to everyone that the Godhead is incomprehensible and uncircumscribable, and I may add boundless, limitless, formless, and whatever adjectives signify the privation of what the Godhead is not. But "What fellowship does light have with darkness?" here also it is appropriate to say, or "What agreement does Christ have with Belial?"[5] What do the holy icons have in common with the idols of pagan gods? If we were worshipping idols, we would have to worship and venerate the causes before the effects, namely Astarte and Chamos the abomination of the Sidonians, as it is written,[6] and Apollo, Zeus, Kronos, and all the other diverse gods of the pagans, who because they were led astray by the devil transferred their worship

[4] This accusation was made by the iconoclastic council of 754. See Pelikan 2, p. 113.

[5] 2 Cor. 6.14-15.

[6] 4 Kings 23.13.

unwittingly from God the maker to the products of His workmanship, and, as it is said, "worshipped the creation instead of the Creator,"[7] slipping into a single abyss of polytheism. We, however, have only one God whom we venerate as Trinity. And in regard to the doctrine of theology, so far from inventing some kind of circumscription or comprehension (perish the idea! for this was an invention of pagan thought), we do not even know that the Godhead exists at all, or what sort of thing it is, as it alone understands about itself. But because of His great goodness one of the Trinity has entered human nature and become like us. There is a mixture of the immiscible, a compound of the uncombinable: that is, of the uncircumscribable with the circumscribed, of the boundless with the bounded, of the limitless with the limited, of the formless with the well-formed (which is indeed paradoxical). For this reason Christ is depicted in images, and the invisible is seen. He who in His own divinity is uncircumscribable accepts the circumscription natural to His body. Both natures are revealed by the facts for what they are: otherwise one or the other nature would falsify what it is, as your opinions imply.

PROBLEMS OF CHRISTOLOGY

3. "But," the heretics say, "the Godhead does not remain uncircumscribed when Christ is circumscribed bodily. If the divinity is united to the flesh by a hypostatic union, the uncircumscribable divinity must be co-circumscribed in the circumscription of the flesh. Neither can be separated from the other, or else some abominable kind of division would be introduced."[8]

[7]Rom. 1.25.

According to the word-play which you call an argument, neither could the Godhead remain incomprehensible in being comprehended—but it was wrapped in swaddling clothes! Nor could it remain invisible in being seen—but it was seen! Nor could it remain intangible in being touched —but it was touched! Nor could it remain impassible in suffering—but it was crucified! Nor could it remain immortal in dying—but it was put to death! In the same way you should understand that the Godhead has also remained uncircumscribable in being circumscribed. For these are properties just as those others are; but the properties of the uncircumscribable nature are those in which Christ is recognized to be God, while the properties of the circumscribed nature are those in which He is confessed to be man. Neither one makes the other into something new, nor departs from what it was itself; nor is one changed into the other (for such a change would produce the confusion which we have refused to admit); but He is one and the same in His hypostasis, with His two natures unconfused in their proper spheres.[9] Therefore you must either accept the "circumscribed," or if not, then take away the "visible" and "tangible" and "graspable" and whatever adjectives are in the same category. Then it would become obvious that you utterly deny that the Word became flesh—which is the height of impiety.

4. According to the heretics, to call Christ a mere man is totally absurd. "Circumscription," they say, "is characteristic of a mere man: therefore Christ is not a mere man, because He is not circumscribed."

You seem to me to be talking complete nonsense when

[8] The iconoclasts were concerned to avoid Nestorianism. See Pelikan 2, p. 116.

[9] Theodore insists on the doctrine of the council of Chalcedon (451), in order to avoid monophysitism.

you keep bringing up your favorite word "uncircumscrib-able." You try to evade our argument with non-argument, to refute what is undemonstrated by your demonstration and what is illogical with your logic. But come into the ring and be utterly overthrown. For Christ did not become a mere man, nor is it orthodox to say that He assumed a particular man, but rather that He assumed man in gen-eral, or the whole human nature.[10] It must be said, how-ever, that this whole human nature was contemplated in an individual manner (for otherwise how could He be seen?), so that He is seen and described, touched and circumscribed, eats and drinks, matures and grows, works and rests, sleeps and wakes, hungers and thirsts, weeps and sweats, and whatever else one does or suffers who is in all respects a man. Therefore we must admit that Christ is circumscribed, although not a mere man (for He is not one of the many, but God made man); or else we may be attacked by the swift serpents of heresy whom you follow, namely those who say that He came only in appearance and fantasy.[11] At the same time we must also admit that He is uncircumscribable, if indeed He is God made man, so that we may drive off the impious dog who babbles that Christ received His origin from Mary.[12] For this is the novel mystery of the dispensation, that the divine and human natures came together in the one hypostasis of the Word, which maintains the properties of both natures in the in-divisible union.

[10]"Orthodox christology had come to the position that there was no separate person of the man Jesus" (Pelikan 2, p. 117). See also Meyendorff, *Christ in Eastern Christian Thought,* p. 55.

[11]Docetics, perhaps including Manichaeans and Paulicians: see Ouspensky, p. 132, Pelikan 2, pp. 225-7.

[12]Probably Arius.

THE MOSAIC COMMANDMENT

5. "The erection of images is completely forbidden," the heretics say, "in the Scripture; for it says, 'You shall not make an idol for yourself, nor any likeness of whatever is in the heaven above or on the earth below or in the waters under the earth. You shall not venerate them, nor shall you worship them, for I am the Lord your God.' "[13]

When and to whom were these words spoken? Before the age of grace, and to those who "were confined under the Law,"[14] and were being taught the monarchy of one divine person; when God had not yet been revealed in the flesh, and the men of antiquity were being protected against foreign idols. This law had to be made for those who through their forefather Abraham had formed a chosen people and fled the abyss of polytheism, because there is one God and Lord of all, "whom no man has ever seen or can see," as it is written.[15] For Him there is no designation, no likeness, no circumscription, no definition, nothing at all of what comes within the comprehension of the human mind. The words of the prophet make this very clear: "To whom did you liken the Lord, or with what likeness did you compare Him?"[16] I pass over the fact that what was utterly forbidden in the case of God was not forbidden in every other case. For He who had given the prohibition to the hierophant Moses immediately afterwards commanded him: "You shall make two cherubim of gold, of hammered work, on the two ends of the mercy seat . . . The cherubim shall spread out their wings above, overshadowing the mercy seat with their wings, their faces one to another . . . and there I will make myself known

[13]Ex. 20.4-5. [15]I Tim. 6.16.
[14]Gal. 3.23. [16]Is. 40.18.

to you, and I will speak with you."[17] And in the book of
Leviticus, the Lord says to Moses, " 'Make a serpent for
yourself, and set it on a pole; and every one who is bitten,
when he sees it, shall live.' So Moses made a bronze ser-
pent, and set it on a pole; and if a serpent bit any man,
he would look at the bronze serpent and live."[18] Now you
see the whole teaching of Scripture; although the angels
are not solid like us; and although the serpent differs from
us by its reptilian shape, nevertheless it was received figura-
tively as a symbol of Christ.[19] If God formerly conde-
scended to be symbolized by a serpent in order to heal
those who were bitten, how could it not be pleasing to Him
and appropriate to set up the image of the bodily form
which has been His since He became man? And if the
symbol in animal form cured those who had been bitten
by its sight alone, how could the holy representation of
Christ's very form do otherwise than hallow those who
see it?

6. "Well, then, God falls into contradiction and op-
poses Himself," the heretics say.

What madness! The prohibition applies to likening the
Godhead to all those creaturely objects such as the sun,
the moon, the stars, or whatever else, upon which idols
are modeled;[20] but the command aims to lead Israel sym-
bolically by means of certain sculptured and modeled forms
as far as possible toward the contemplation and worship
of the one God. Is not even the very pattern of the whole
tabernacle a distinct prefiguration of worship in the Spirit,
roughly sketched in symbolic visions for the great Moses
by the God of all?[21]

[17]Ex. 25.18-22. [20]Deut. 4.19.
[18]Num. 21.8-9. [21]Heb. 9.
[19]John 3.14.

MATTER AND SPIRIT

7. "It is a degradation," the heretics say, "and a humiliation, to depict Christ in material representations.[22] It is better that He should remain in mental contemplation, as He is formed in us by the Holy Spirit, who sends into us a kind of divine formation through sanctification and righteousness. For the Scripture says, 'What profit is an image when its maker has shaped it, a metal image, a teacher of lies? For the workman trusts in his own creation.'[23] And in another place: 'A tree from the forest is cut down, and worked with an axe by the hands of the craftsman; men deck it with silver and gold.' "[24]

You cannot seem to avoid repeating yourself like a blind man going in circles, as you keep maliciously shifting from one thing to another. The very thing which you call indecent and abject is actually godlike and sublime because of the greatness of the mystery. For is it not glorious for the lofty when they humble themselves, as it is shameful for the lowly when they exalt themselves?[25] Thus for Christ, who remains on His own summit of divinity, glorified in His immaterial indescribability, it is glory to be materially circumscribed in His own body because of His sublime condescension toward us. For He who had created everything became matter (that is, flesh). He did not refuse to become and to be called what He had received, and it is characteristic of matter to be circumscribed materially. As for your argument that He is sufficiently represented for mental contemplation, because He is formed again in us through the Holy Spirit—that belongs to the

[22]Contempt for matter is more characteristic of the pagan (neoplatonic) tradition than of the Hebrew tradition.

[23]Hab. 2.18. [24]Jer. 10.3-4. [25]Compare Luke 14.11.

subject of baptism. Besides, we are not talking about how
the "very stamp of the hypostasis"[26] of God the Father is
depicted in us, but about how we depict His human image
with material pigments. If merely mental contemplation
were sufficient, it would have been sufficient for Him to
come to us in a merely mental way; and consequently we
would have been cheated by the appearance both of His
deeds, if He did not come in the body, and of His suffer-
ings, which were undeniably like ours. But enough of this!
As flesh He suffered in the flesh, He ate and drank like-
wise, and did all the other things which every man does,
except for sin.[27] And so what seems dishonor to your way
of thinking is actually true honor to the greatly honored
and exceedingly glorious Word. Would you please stop
ignorantly dragging out scriptural verses to use against us,
taking the words spoken against the pagans in regard to
the forms of idols, and misapplying them to the icon of
Christ? For what person with any sense does not under-
stand the difference between an idol and an icon? That
the one is darkness, and the other light? That the one is
deceptive, the other infallible? That the one belongs to
polytheism, but the other is the clearest evidence of the
divine economy?

THE IMAGE AND ITS ORIGINAL

8. "Why is not the same thing written," the heretics
say, "about the icon as about the cross? For the apostle
says, 'The word of the cross is folly to those who are
perishing, but to us who are being saved, it is the power
of God.'[28] He also says, 'Far be it from me to glory except
in the cross of Christ!'[29] Many other words of praise occur

[26]Heb. 1.3. [27]Compare Heb. 4.15. [28]I Cor. 1.18. [29]Gal. 6.14.

in the Scriptures. Where, then, can you show such a passage, and from what author, concerning the icon?"

Tell me, you over-confident man, which did he praise, and in which did he glory, in the cross, or in a representation of the cross? Obviously in the former; but the copy shares the glory of its prototype, as a reflection shares the brightness of the light. For whatever is said about the cause, the same can in all respects be said about the effect. In the case of the cause, it is said properly, because it is true by nature; while in the case of the effect, it is not said properly, because it is true by identity of name. Thus also, as Christ has been proclaimed from the beginning, the proclamation about His image has followed according to its relationship with Him. You have as many testimonies concerning Christ's image as you have concerning Christ Himself. Likewise, as much is said about the representation of the cross as about the cross itself. Nowhere does the Scripture speak about representation or image (since these have the same meaning); for it is illogical to expect such a mention, inasmuch as for us the effects share in the power of the causes. Is not every image a kind of seal and impression bearing in itself the proper appearance of that after which it is named? For we call the representation "cross" because it is also the cross, yet there are not two crosses; and we call the image of Christ "Christ" because it is also Christ, yet there are not two Christs. It is not possible to distinguish one from the other by the name, which they have in common, but by their natures. In the same way the divine Basil says that the image of the emperor is called "the emperor," yet there are not two emperors, nor is his power divided, nor his glory fragmented; and that the honor given to the image rightly passes over to the prototype (and vice versa).[30]

9. "It happens," the heretics say, "that as many are

[30]*On the Holy Spirit* 18.45 (PG 32.149).

called Lords and Christs as there are different icons, and from this comes polytheism; but we for our part have one Lord and God whom we worship."

So what? Is not the Father Lord? Is not the Son Lord? Is not the Spirit Lord? As each of them is also God? Of course. So then are there three Gods and Lords? What impiety! There is one God and Lord. And, sir, you must understand the same in the case of the icons. Even if there are many representations, still there is only one Christ, and not many; just as the same one is Lord, and not different individuals. For just as in the former case the single appellation of "God" and "Lord" applies inclusively to the nature which cannot be divided into its three persons, so in the latter case the use of an identical name brings together the many representations into one form; and so your objection is invalid.

THE UNIQUENESS OF THE EUCHARIST

10. "We grant," the heretics say, "that Christ may be represented, but only according to the holy words which we have received from God Himself; for He said, 'Do this in remembrance of me,'[31] obviously implying that He cannot be represented otherwise than by being remembered. Only this image is true and this act of depiction sacred."[32]

It is sufficient for your refutation that you are clearly contradicting yourself, when you admit that Christ is circumscribed, although previously you denied this. But since it is not right to leave any of your propositions unchallenged, let us proceed to their refutation one by one. What

[31] I Cor. 11.24.
[32] This is the position taken by Constantine V and the council of 754. See Pelikan 2, pp. 109-10.

do you say about these very things to which the priest refers in holy words and hymns? Are they an image or the truth? If they are an image, what absurdity! You go from blasphemy to blasphemy, like those who step into some sort of mud, and in trying to get across fall with both feet into something even more slippery. For you have chosen to fall into atheism in order to keep your argument consistent. But if they are the truth—as indeed they really are, for we confess that the faithful receive the very body and blood of Christ, according to the voice of God Himself—why do you talk nonsense as if the sacraments of the truth were mere symbols? "Do this in remembrance of me," He said, and rightly; for this mystery sums up the whole dispensation, signifying the whole figuratively by its most important part. The fact that He said, "Do this in remembrance of me," does not mean that this is permitted to everyone, but only to those who hold the priestly office. Neither indeed did He forbid us to celebrate the other mysteries. We make memorials of His Nativity and Theophany. At one time we carry branches to represent His sitting on the foal of an ass, and at another time we kiss one another as a sign of His resurrection. I pass over the ascent to the temple and the tempter's temptation, in imitation of which we keep the forty days' abstinence, and other observances which have the same meaning. "Do all these things in remembrance of me," we must understand that the Word has commanded, including them in silence under the heading of the most prominent mystery.

Or is it not right to understand the same in the case of His corporeal appearance on paper, for example the divinely-written Gospels? He nowhere told anyone to write down the "concise word,"[33] yet His image was drawn in writing by the apostles and has been preserved up to the present. Whatever is marked there with paper and

[33]Rom. 9.28; Is. 10.23.

ink, the same is marked on the icon with varied pigments or some other material medium. For the great Basil says, "Whatever the words of the narrative offer, the picture silently shows the same by imitation."[34] For this reason we are taught to draw not only what comes into our perception by touch and sight, but also whatever is comprehended in thought by mental contemplation. Therefore the custom has been handed down from the beginning not only of representing angels, but also of painting the future judgment, with those standing on the right and on the left having more gloomy or more joyous expressions. One thing only is utterly uncircumscribable, the Godhead: which no thought can comprehend, no sound can designate for the hearing, as it is by nature. Likewise its circumscription is impossible. Everything else, since it is defined and comprehended by the mind, can also be circumscribed by either hearing or sight (the two senses being equivalent).

11. "What, then, is it that is shown?" the heretics ask. "Either the image of Christ or Christ Himself, but not both, for the shadow and the truth are not the same thing. And how could one say that each is in the other, or that either one is in the other? The absurdity is obvious."

No one could ever be so insane as to suppose that shadow and truth, nature and art, original and copy, cause and effect are the same in essence;[35] or to say that "each is in the other, or either one is in the other." That is what one would have to say if he supposed or asserted that Christ and His image are the same in essence. On the contrary, we say that Christ is one thing and His image is another thing by nature, although they have an identity in the use of the same name. Moreover, when one con-

[34]Hom. 19 (PG 31.509).

[35]The iconoclasts believed that a genuine image must have the same essence as its original. See Pelikan 2, p. 109.

siders the nature of the image, not only would he not say
that the thing he sees is Christ, but he would not even
say that it is the image of Christ. For it is perhaps wood,
or paint, or gold, or silver, or some one of the various
materials which are mentioned. But when one considers
the likeness to the original by means of a representation,
it is both Christ and the image of Christ. It is Christ by
the identity of name, but the image of Christ by its rela-
tionship. For the copy is a copy of its original, just as a
name is the name of that which is named. Here is the
proof: it is written, "Josiah raised his eyes to the tomb of
the man of God who had predicted these things. Then he
said, 'What is yonder monument that I see?' And the men
of the city told him, 'It is the man of God who came from
Judah . . .' And he said, 'Let him be; let no man move
his bones.' "[36] Do you understand what the Scripture says?
It calls the tomb "the man of God," naming the monu-
ment after the body lying in it. How much more legitimate
it is to name the prototype after its image! In another
place, God says to Moses, "Make for me two cherubim
of gold,"[37] not "images of cherubim." So now that you
see how the copy is called like the original by identity of
name, stop attempting folly and trying to use logic illogi-
cally against the truth.

12. "In what sense can you say that the divinity of
Christ is in the icon? By nature, since they are venerated
together, or not? If His divinity is in the icon, there is
circumscription; but if not, the veneration is impious, for
one worships what the icon is not rather than what it is
called. Christ's flesh is always venerated together with His
divinity, because they are united inseparably; but the icon
is not united inseparably with Him."

You are still talking the same absurdities. Since the

[36]4 Kings 23.16-18. [37]Ex. 25.18.

archetype and the image are not the same thing, because the one is truth but the other is a shadow, why do you image that your attack is so clever? In the case of the Lord's body, because of the conjunction of natures, His divinity is conjointly both venerated and glorified, although it is subject to the circumscription of the flesh. How else could it be, since the flesh is tangible, graspable, and visible, and in no way takes on the alien properties of the uncircumscribable nature because of the union? Accordingly, as it is said, the flesh even suffered without the impassible essence sharing the suffering. But the case of the icon is entirely different. For where there is present not even the nature of the flesh which is portrayed, but only its relationship, much less could you say that there is present the uncircumscribable divinity: which is located in the icon, and is venerated there, only insofar as it is located in the shadow of the flesh united with it. What place is there where divinity is not present, in beings with or without reason, with or without life? But it is present to a greater or lesser degree according to the capacity of the nature which receives it. Thus if one says that divinity is in the icon, he would not be wrong, since it is also in the representation of the cross and in the other sacred objects; but divinity is not present in them by a union of natures, for they are not the deified flesh, but by a relative participation, because they share in the grace and the honor.

THE PROPER VENERATION OF IMAGES

13. "How can they say," the heretics ask, "that the image should not be displayed without veneration? On the contrary, we ought to display the image without venerating it, because equally with hearing the sight enables us to

return to the events and remember them; while at the same time we avoid the unspiritual effect of material representation. For 'God is spirit, and those who worship Him must worship in spirit and truth,' as the Scripture says."[38]

If you admit that the acuity of sight is equal to that of hearing, which is true, you must take the equivalence seriously: let the sacred Gospel book also remain only for hearing, and not be venerated (although it is holy). But if this is foolish, why is not your suggestion foolish also? For you yourself have judged them equal. Or why do you not say that each is venerable, but that each conflicts with itself in giving help and harm at once? So whether in an image, or in the Gospel, or in the cross, or in any other consecrated object, God is evidently worshipped "in spirit and in truth," as the materials are exalted by the raising of the mind toward God. The mind does not remain with the materials, because it does not trust in them: that is the error of the idolators. Through the materials, rather, the mind ascends toward the prototypes: this is the faith of the orthodox.

14. "Is the inscription to be venerated," the heretics ask, "or the icon, of which the title is inscribed? Is it exclusively one or the other, and not both? How?"

That is rather like asking, "Is it right to venerate the Gospel book or the title on it? The representation of the cross or the inscription on it?" I might add also in the case of our own kind, "the man, or his name?" perhaps of Paul and Peter and each of the individuals of the same species. Would not that be stupid, not to say ridiculous? What is there, of all the things before our eyes, that is nameless? How can the thing which is named be separated

[38]John 4.24. Many Christians, especially in the West, have held the view that pictures are "books for the illiterate" but should not be venerated. See Ouspensky, pp. 133-4.

in honor from its own appellation, so that we may offer veneration to the one and deprive the other of it? These are relationships, for a name is by nature the name of something which is named, and a sort of natural image of that to which it is applied. Therefore the unity in veneration is not divided.

THE CROSS AND THE ICON

15. "Should the cross be venerated more than the icon?" the heretics ask. "Should it be venerated equally, or in a lesser degree?"

Since there is a natural order in these things, I think you are speaking superfluously. If by "the cross" you mean the original cross, how could it not have priority in veneration? For on it the impassible Word suffered, and it has such power that by its mere shadow it burns up the demons and drives them far away from those who bear its seal. But if you mean the representation of the cross, your question is not intelligent. The effects receive differing honor just as much as the causes differ, since whatever is received for some use is less honored than that for the sake of which it is received. Thus the cross is received for the sake of Christ, because it was formerly an instrument of condemnation, but was later hallowed, when it was accepted for the use of the divine passion.

ETYMOLOGICAL ARGUMENTS

16. "There is no difference," they say, "between 'idol' and 'icon,' for both words mean the same. 'Idol' comes from εἶδος, 'form' in general (for its proper signification

is not 'that which is seen'); 'icon' comes from ἐοικός, in the sense of 'likeness.'[39] A likeness is simply that which is not its prototype, and so are both 'idol' and 'icon.' For both words amount to the same in meaning. But to venerate an idol, when claiming to venerate Christ circumscribed, is impious; for it is utterly forbidden by the word of truth."

From the same reasoning, that the likenesses are not the Godhead, but that they usurp the truth, there is no difference; because the Scripture forbids equally not only the imagery of idols, but also statues and likenesses and anything else of the sort. For it says, "You shall make for yourselves no gods made with hands and erect no graven image or statue, and you shall not set up a figured stone in your land, to venerate them; for I am the Lord your God."[40] And elsewhere: "Has not the workman made an icon, or the goldsmith having melted gold, gilt it over, and made it a likeness?"[41] For the danger of idolatry comes from both icon and idol. Therefore since the name of icon has been forbidden from of old for the likeness of God according to His limitless nature, we must not for that purpose use it or anything of the same order. We use the word "icon" rather in reference to the bodily form of Christ; as in the beginning, in the creation of the world, this was already indicated at the formation of the first man. For God said, "Let us make man in our image (icon) and likeness."[42] And again the word is used in the divine question, "Whose image (icon) is this?"[43] So from these passages we obtain the proper use of the word "image" or "icon"; by transference we use the words "form" (χαρα-κτὴρ) and "likeness" (ὁμοίωμα); but we never use the word "idol" at all, even though it has the same meaning of

[39]"Idol" means "form" because it means "that which is seen." Otherwise this etymological argument is valid enough.

[40]Lev. 26.1. [42]Gen. 1.26.
[41]Is. 40.19. [43]Mat. 22.20.

"similitude." For it is restricted to the ancient worshippers of the creation and to anyone now who does not venerate the Trinity indivisible in nature, in glory, and in power, or who does not confess the incarnation of the Word. For as it is written, "Let those gods perish who did not make the heavens and the earth"[44] but themselves were made from wood and stone and all kinds of materials, and are divided among themselves and conflicting not only in nature but also in will, glory, and worship. And they will bring out to us like captives the icons of our Lady and of all the other saints.

THE ICONS OF THE SAINTS

17. The heretics say that it is not right to depict and to venerate the images of the saints.[45] Why? "Because," they say, "it does not honor those who have obtained heavenly glory to represent them in material pictures. Instead let us keep their memorial in words, which is more valuable than that in paintings, because it is more useful."

They say the same thing in the case of Christ; and the refutation is evident, not to repeat our argument. For hearing is equal to sight, and it is necessary to use both senses. Whoever takes away the one would have to remove the other also along with it. And by removing both he would be quite able to abolish the veneration of every venerable person, if we are not mistaken.

18. "But," the heretics say, "not everyone who is depicted is worthy of veneration, this man or that man,

[44]Jer. 10.11.

[45]Some iconoclasts, including Constantine V, seem to have opposed the cult of saints. See Pelikan 2, p. 111.

unimportant persons, perhaps, and not praiseworthy."

But here we have saints who are venerable and glorious, because they have earned honor by the blood of martyrdom or by a holy way of life.

DIFFERENCES IN VENERATION

19. "Then," the heretics say, "veneration would turn out to be of many kinds. But there is only one kind of veneration and not many."

Worship is unique, and belongs to God alone; but other kinds of veneration belong to others. We venerate kings and rulers, servants venerate their masters, children venerate their parents: but not as gods. Although veneration has the same outward form, it varies in intention. For these are human beings, and receive respect according to the honor due them, whether by law, by fear, or by affection. Therefore, if one knows the diversity of veneration, when he venerates the prototypes through their representations, he has given the veneration properly so-called in the proper way to God alone, but the analogous types of veneration to those others who are depicted, to the Theotokos as Theotokos and to the saints as saints.

There are holy books set out to be seen in all the churches of God, for the eyes of all men, just as the words of the books are set forth for the hearing. They are venerable in the same degree, because they have equal force, or perhaps those that are seen take precedence as sight is the more noble sense.

Besides, what shall we do with the custom which has prevailed from the beginning up to the present, as can be recognized from every temple of God with its holy monuments? Did the choir of holy fathers act impiously? Did the blameless Church practice idolatry? And when will the

If anyone should rashly confuse the relative veneration of Christ in the icon with the veneration of idols, and should deny that it is a veneration of Christ Himself (although the great Basil says that the glory of the prototype is not divided by the glory which is given to the copy[47]), he is a heretic.

If anyone should say that, when the image of Christ is displayed, it is sufficient neither to honor nor to dishonor it, thus refusing it the honor of relative veneration, he is a heretic.

If anyone should transfer the Scriptural prohibitions of idols and misapply them to the holy icon of Christ, so as to miscall the Church of Christ a temple of idols, he is a heretic.

If anyone should say that, when he venerates the icon of Christ, he is venerating Christ's divinity present naturally in the icon, rather than only insofar as the icon is the shadow of the flesh which is united to the divinity (since the Godhead is everywhere), he is a heretic.

If anyone should judge the raising of the mind to the prototypes by means of the holy icons to be base and unspiritual (because he thinks that without them he is raised by hearing to the vision of the archetype), and should not give equal respect to the memorial depicted in silence as to the narration in speech (as the great Basil says[48]), he is a heretic.

If anyone should forbid the icon of Christ equally with the symbol of the cross to be both drawn in every place and displayed for the salvation of God's people, he is a heretic.

If anyone should not offer to the icon of the Theotokos and to the icons of all the other saints the veneration due to the Theotokos as Theotokos and to the other saints as

[47]*On the Holy Spirit* 18.45 (PG 32.149).

[48]Hom. 19 (PG 31.509).

Church be purified from idols, and by whom? Obviously your opposition is from Antichrist. And how will the long-standing observation of ancient customs and traditions be overthrown?

Inspired by God, the fathers decree that we should stand firm even against a logical demonstration (although the decree is superfluous in this case), for they say, "Let the simplicity of faith be stronger than the demonstrations of reason." And elsewhere they say, "Let the ancient customs prevail." Or if you miscall the Church of God a temple of idols because of the erection of icons, how are you not fulfilling the work of all the heresies? Stand back with the opposing side; and, unless you repent, listen to the voice stoning you, as it were, and forbidding you to touch the mountain of the Church like some heretical beast.[46]

ANATHEMAS

20. Therefore, if anyone denies that our incarnate Lord Jesus Christ is circumscribed by the flesh, while remaining indescribable according to His divine nature, he is a heretic.

If anyone should argue that, because the flesh of the Word is circumscribed, His divinity is circumscribed together with the flesh; and if in this argument he fails to distinguish the two natures in the single hypostasis according to their natural properties (because neither one excludes the other in the inseparable union), he is a heretic.

If anyone calls the circumscription of the Word's bodily form neither the icon of Christ, nor Christ by identity of name, but miscalls it an idol of deception, he is a heretic.

[46]Ex. 19.13.

saints (according to the differing veneration of the Mother of God and of her fellow servants), but should claim that the salvific ornament of the Church is an idolatrous invention, he is a heretic.

If anyone should not number with the other heresies the heresy which attacks the holy icons (since it alienates its followers from God as much as the others do), but should say that fellowship with these people is a matter of indifference, he is a heretic.

If anyone should overextend the honor of Christ's icon and say that he will not approach it, for it will not benefit him unless he is first purified from all sin, he is a fool.

Second Refutation of
The Iconoclasts

Because the word of truth is single and unshakable by nature, it is not subject to divisions of opinion or changes with time; for it is always glorifying and proclaiming the same doctrines, since it is free from all subtraction or addition. The fables of falsehood, however, because they are fragmented and diverse in opinion, always shifting from one position to another, proclaim one thing now, then glorify the opposite, and never stand still in the same place, since they are subject to the pressures of variation and change. That is how it is with the barking of the iconoclasts: at one time they blasphemously miscall the icon of our Lord Jesus Christ an idol of deceit;[1] at another time they do not say so, but say instead that the depiction is good, because it is useful for education and memory, but is not for veneration.[2] For this reason they assign the icon a place high up in the church, fearing that if it is located in a lower place, where it could provide an opportunity for veneration, it may cause them to fall into idolatry.

Who would not be amazed at their witless wisdom? The very fact that they fear the low position and the veneration of the icon provides a basis for the suspicion of idolatry. The removal of the lower icons will not be enough to keep their opinions from error if they leave the images higher on the walls. In the books of the Kings, no one pleased

[1]Compare *Ref.* 1.2. [2]Compare *Ref.* 1.13.

God but David, Hezekiah, and Josiah, who removed the
lofty idols along with those lower down.[3] So if they should
seek to do God perfect service according to their under-
standing, or rather to do perfect impiety in their misguided
notions, they would not leave any consecrated house under
heaven which they would not strip of ornament, nor any
holy pictures hanging on the walls which they would not
commit to the fire. But I have said enough about these
heretics, trying as well as I can with my limited intelligence
to destroy their irrational opposition and contrary argu-
ments. Now that they have been hemmed in by our proofs,
they admit that our Lord Jesus Christ can be portrayed,
but not that His icon should be set up and venerated; and
then they try to shake the understanding of the simpler
people by saying that in venerating the icon they are wor-
shipping the creation instead of the Creator. My present
inadequate treatise will deal with this accusation by the
opposition of two speakers—an orthodox, that is, and an
iconoclast—so that the force of the arguments may be
easier to see and understand.

CHRIST AS PROTOTYPE OF HIS IMAGE

1. *Orthodox:* Do you admit that since the Son and
Word of the Father has become flesh, He is circumscribed
by the flesh, while remaining uncircumscribable in His
divine nature?

Heretic: I agree, for how could I not, since the theolo-
gian fathers declare this? Gregory says, "Circumscribed in
the body, uncircumscribable in the spirit";[4] and Athanasius
says, "Invisibly recognized as God and truly being so, but

[3]4 Kings 18.3-4; 4 Kings 23.4-20; 2 Chron. 23.4-20.
[4]Gregory of Nazianzus, Ep. 101 (PG 37.177).

visibly touched as man and truly existing as such."[5]

2. *Orthodox:* Do you not also admit that this circumscription, namely the image of Christ, is worthy of veneration?

Heretic: Not at all; because none of the divinely inspired fathers has said this either. But I shall ask you in return, and you must answer: where is it written in the Old or New Testament that we should venerate an image?

3. *Orthodox:* Wherever it is written that we should venerate the prototype of the image.

Heretic: "You shall venerate the Lord your God, and Him only shall you worship."[6] This is what is written. We are commanded to venerate the Lord, not any kind of "prototype," much less an image, as you say.

4. *Orthodox:* We are not talking about theology, sir, in which there is no question of resemblance or likeness; but about the divine economy, in which we see the prototype and the copy, if indeed you confess that the Word assumed flesh and became like us.

Heretic: When the Scripture says, "You shall venerate the Lord your God, and Him only shall you worship," does not the word command us to offer veneration to the Son together with the Father?[7]

5. *Orthodox:* Obviously; but this law was not given to the men of antiquity as if God had assumed flesh, for "No one has ever seen God," as the Scripture says.[8] When

[5]*Against Apollinarius* 2.2 (PG 26.1133).

[6]Matt. 4.10, Luke 4.8, Deut. 6.13.

[7]As if the parallel clauses indicated two objects of worship (the Father and the Son), and thus foresaw the incarnation.

[8]John 1.18.

He became flesh and entered into circumscription, the uncircumscribable one was seen, and the intangible and invisible one became subject to bodily sight and touch. He is venerated together with the Father, because He is God equally with the Father; but He is venerated also in His image, of which He is the prototype, because He became man like us in everything but sin.

Heretic: Concerning Christ, all the inspired Scriptures say clearly that He is worthy of veneration, for it is written, "Let all God's angels venerate Him";[9] but concerning the prototype and the image, the Scriptures say nothing.

6. *Orthodox:* Concerning Christ, when it is written, "Let all God's angels venerate Him," what else can we understand but that it is written concerning the prototype? For He became man after being God, and every man is the prototype of his own image. There could not be a man who would not have a copy which is his image. Obviously Christ also, inasmuch as He has been made like us in everything, is the prototype of His image, even if it is not written explicitly. So when you ask, "Where is it written that we should venerate the image of Christ?" then you should hear the answer, "Wherever it is written that we should venerate Christ"; if indeed the copy is inseparable from the prototype.

Heretic: But since it is not written that Christ is the prototype of His image, your statement cannot be accepted, because it is not included in the traditional confession of our faith.

7. *Orthodox:* Many teachings which are not written in so many words, but have equal force with the written teachings, have been proclaimed by the holy fathers. It is not the inspired Scripture but the later fathers who made

[9]Heb. 1.6, Deut. 32.43.

clear that the Son is consubstantial with the Father, that the Holy Spirit is God, that the Lord's mother is Theotokos, and other doctrines which are too many to list. If these doctrines are not confessed, the truth of our worship is denied. But these doctrines were confessed at the time when need summoned them for the suppression of heresies which were rising up against the truth. So after all how is it surprising, although it is not written that Christ is the prototype of His image, if the times now require this to be said in opposition to the growing iconoclast heresy, since the truth is so clearly evident? For if He is not the prototype of His own image, neither is He incarnate, but remains outside circumscription in the boundlessness of His divinity. But if He is incarnate and visible like us, why do you not attribute to Him the same characteristics as to every other man in consequence of this likeness?

Heretic: Because, although Christ is God and man, He is not a mere man as if He were one like us, neither consequently is it right to say that He is the prototype of His image.[10]

8. *Orthodox:* When the fathers said that Christ is not a mere man, they did not say it, I judge, intending to deny His circumscription, but referring to His being both God and man, which is not characteristic of one like us. In this respect we are all called "mere men." But insofar as He is circumscribed, He is the prototype of His own image, just as if He were one like us; yet He is not therefore a mere man.

Heretic: I admit that Christ is circumscribed, but not that He has the relationship of prototype.

9. *Orthodox:* How could He be circumscribed if He did not have the relationship of prototype? What we call

[10]Compare *Ref.* 1.4.

"circumscribed" is simply that which is a prototype. For that which is circumscribed can serve as a model for the image which is drawn as a copy. Therefore when you admit that Christ is circumscribed, you must grant, whether you like it or not, that He is the prototype of His image, as every man is of His own likeness. Accordingly the divine Basil says, "Let Christ, who presides over the contest, also be portrayed in the painting."[11] By saying this, he has fittingly shown that Christ is the prototype of His image, if indeed everyone who is portrayed in a painting is copied from the form of the prototype.

Heretic: What kind of veneration does the prototype share with its copy?

10. *Orthodox:* The same as the life-giving cross shares with its own representation.

Heretic: Where did you get this idea? I will not accept you as a new law-giver.

11. *Orthodox:* The doctrine comes from two men who speak God's words. Dionysius the Areopagite says, "Truth in the likeness, the archetype in the image; each in the other except for the difference of essence."[12] The great Basil says, "He who looks at the emperor's image in the public square, and calls the one in the picture 'emperor,' does not acknowledge two emperors, the image and him whose image it is; nor if he should say, pointing to the one drawn in the picture, 'This is the emperor,' does he deprive the prototype of the name of emperor. Rather he confirms the honor of the emperor by recognizing his image. For if the image is the emperor, all the more must he be emperor who has provided the cause for the image."[13] And else-

[11]Hom. 17.3 (PG 31.489).
[12]*Eccl. hier.* 4.3.1 (PG 3.473).
[13]Hom. 42.4 (PG 31.608).

where Basil says, "In general the artificial image, modeled after its prototype, brings the likeness of the prototype into matter and acquires a share in its form by means of the thought of the artist and the impress of his hands. This is true of the painter, the stonecarver, and the one who makes statues from gold and bronze: each takes matter, looks at the prototype, receives the imprint of that which he contemplates, and presses it like a seal onto his material."[14]

HONOR AND VENERATION

Heretic: Even if the fathers have reasoned in this manner, they certainly have not stated that the prototype and the copy receive a common veneration.

12. *Orthodox:* The divine Basil says that the recognition of the copy confirms the honor of the prototype. What else can you understand but that there is one honor or veneration of both?

Heretic: I agree about the honor, but not about the veneration; for the change of words is yours, not from the fathers whom you cite.

13. *Orthodox:* What if you hear the blessed Athanasius say, "In the image of the emperor are his appearance and form, and in the emperor is the appearance which is in the image. The likeness in the image of the emperor is unchanged, so that whoever looks at the image sees the emperor in it; and conversely whoever sees the emperor recognizes that this is the man in the image. Because the likeness is not changed, when someone wishes to see the emperor after seeing the image, the image may say to him,

[14]Ps. Basil, *Against Eunomius* 5 (PG 29.724).

'I and the emperor are one, for I am in him, and he in me. Whatever you have seen in me, you see the same in him; and whatever you see in him, you see the same in me.' Therefore whoever venerates the image, venerates the emperor in it, for the image is his form and appearance."[15] In the same way (if I may add something of my own), whoever venerates the symbol of the cross venerates in it the life-giving cross itself. For the symbol is its form and delineation.

Heretic: Refrain from speaking about the cross in this connection, for it is the invincible trophy of the devil's defeat.

14. *Orthodox:* Then you refrain from speaking of the icon of Christ, for He is the savior of the world. Through Him the cross, which formerly was an instrument of destruction, has become a symbol of immortality because He was stretched out on it.

Heretic: But it is not permissible for the image of Christ to share His veneration, nor to be called by the same name as Christ is called.

15. *Orthodox:* I shall give you an equivalent proposition: it is not possible for the representation of the cross to share the veneration of the life-giving cross itself, nor to be called by the same name as the life-giving wood is called.

Heretic: Enough of this foolishness! The veneration of both is one and the same; and what the life-giving wood is called, its representation is also named, for both are the cross.

[15]*Against the Arians* 3.5 (PG 26.332).

THE RELATION OF THE IMAGE
TO ITS PROTOTYPE

16. *Orthodox:* You yourself are giving me the victory, since I can make an equivalent statement. In the same manner, the veneration of Christ is one and the same as that of His representation; and what Christ is called, His own image is also named. For both are Christ, as the teachings of the inspired writers cited above have made clear. Whatever is said concerning the prototype, the same may be said also concerning the copy. In the case of the prototype it is said synonymously or properly, but in the case of the copy it is said homonymously or figuratively.

Heretic: What do you mean by these words? I do not yet understand you clearly.

17. *Orthodox:* I mean that the name "cross" is given to that on which Christ was lifted up both because of the signification of the word and because of the nature of the life-giving wood. Its representation, on the other hand, is called "cross" because of the signification of the word, but not because of the nature of the life-giving wood. For it is made from some kind of wood, or gold, or silver, or stone, or some other material delineation. It shares the name of the prototype, as well as its honor and veneration, but it has no part in its nature. Therefore, by whatever names the life-giving cross is called, its representation also is called by the same names. If we should say that the life-giving cross is "the glory of the world," likewise its representation is called "the glory of the world." If we call it "light and life," likewise its representation is called "light and life." If we call it "torch of demons," likewise its representation is called "torch of demons."[16] And in every case the copy

[16]The reference is to liturgical texts of the feast of the Exaltation of the Cross (Sept. 14) and of the third Sunday of Lent.

is called by the name which signifies the prototype.

This principle also applies to Christ and His icon. For Christ is called "very God" and also "man," because of the signification of the names and because of the natures of divinity and humanity. His image, on the other hand, is called "Christ" because of the signification of the name, but not because it has the nature of divinity and humanity. For it has its quality from painting with colors, perhaps, or assembling variegated stones, or the sculptor's art, or gold, or silver, or some other material delineation. It shares the name of its prototype, as it shares also the honor and veneration; but it has no part in the nature of the prototype. Therefore, by whatever names Jesus Christ is called, His image is called by the same names. If we should say that Christ is "the Lord of glory," in the same way his image is called "the Lord of glory."[17] If we should say that Christ is "the power of God" and "the wisdom of God," likewise also His image is called "the power of God" and "the wisdom of God."[18] If we should say that Christ is "the son of man," likewise also his image is called "the son of man." Moreover, when God the Word himself says, "I am the light of the world,"[19] His image may say the same by its inscription. Again, when Christ says, "To me 'every knee shall bow, in heaven and on earth and under the earth,' "[20] His image may also say this by its inscription. Again, when Christ says, "I am the life and the resurrection,"[21] His image may also say this by its inscription. And by whatever names the inspired Scripture calls the Savior, we must be able to call His icon by the same names.

Heretic: You are insisting so much on the identity that you seem to say that the copy is nothing other than the prototype itself. For how did every knee bow, or how

[17]1 Cor. 2.8. [20]Phil. 2.10.
[18]1 Cor. 1.24. [21]John 11.25.
[19]John 8.12, 9.5.

would every knee bow, on heaven and on earth and under the earth, to the icon of Christ?

18. *Orthodox:* You should have paid attention to what the confessor Athanasius says: "In the image of the emperor are his appearance and form, and in the emperor is the appearance which is in the image . . . The image may say, 'I and the emperor are one, for I am in him, and he in me. Whatever you have seen in me, you see the same in him; and whatever you see in him, you see the same in me.' Therefore whoever venerates the image, venerates the emperor in it, for the image is his form and appearance."[22] And to what the divine Cyril says: "Just as if someone should look at a well-painted image and be amazed by the appearance of the emperor, and because he is able to see in the picture everything which is visible in the emperor, should conceive a desire to see the emperor himself. To him the painting might well say, 'He who has seen me has seen the emperor;' and 'I and the emperor are one, as far as likeness and accurate resemblence are concerned;' and 'I am in the emperor and the emperor is in me, according to the appearance of his form.' For the painting fully conveys his appearance, and the appearance of the painting is preserved in him."[23] If you had heeded these fathers, you could have understood that when Christ is venerated, His image is also venerated, because it is in Christ; and when His image is venerated, Christ is venerated, for He is being venerated in it. Since admittedly every knee bows to Christ in heaven and on earth and under the earth, surely you must admit that to His image also, as it is in Christ, every knee bows in heaven and on earth and under the earth. So what is said applies to the name only and the identity of veneration, not to an identity of material between the

[22]*Against the Arians* 3.5 (PG 26.332).
[23]Cyril of Alexandria, *Thesaurus* (PG 75.184-185).

prototype and the image; for the material cannot participate in the veneration, although he who is depicted appears in it for veneration.

To confirm what has been said we would do best to support the statement with patristic testimony. The holy Sophronius, as you know, in his *Miracles of the Martyrs Cyrus and John,* has said the following, word for word: "When we came into a certain finished temple, awesome and glorious in appearance, touching the very heavens in height, when we were inside, we saw a great and marvelous icon, with the Lord Christ painted in color in the center; on the left Christ's mother, our Lady, the Theotokos and ever-virgin Mary; and on the right John the baptizer of the Savior and His forerunner, who venerated Him by leaping in the womb (since he could not be heard speaking because he was inside); and below, some of the choir of apostles and prophets and of the company of martyrs. With these happened to be the martyrs themselves, Cyrus and John. Standing before the icon they fell down before the Lord, bending their knees, bringing their heads to the floor, and interceding for the recovery of the young man." A little later, he says, "Standing a short distance from the icon, and coming near, they said, 'Do you see how the Lord is unwilling to grant you a cure?' " And later he says, "Coming to the icon a third time, they used the same words as before; and after they had prayed for a long time, they accomplished what they were bidden and exclaimed, 'Christ has had pity as He is merciful, and has nodded assent, and has said, "Give him his medicine before the icon." ' "[24] Do you see that the martyrs fell down before the icon as though venerating Christ Himself? From the icon also came a voice as of Christ Himself assenting to their entreaty. That which martyrs have venerated, the angels equally may also venerate.

[24]*Miracles of Sts. Cyril and John* (PG 87C. 3557-3560).

Heretic: What you tell is merely a vision, even if it is recounted by a saint, and it does not give authority for a dogmatic statement.

19. *Orthodox:* I agree that it is a vision, but the saint would not have related the story if it were not true. The dogmatic statement has been demonstrated previously; we have brought in the vision here for illustrative purposes. Illustrations are called, and truly are, the eyes of what is said. Moreover, the blessed Athanasius tells something relevant and even more paradoxical, how the copy has so much in common with the prototype that the suffering of Christ's icon seemed to be Christ's own suffering. This is his story: "Come, lift up the eyes of your understanding and see this new sight. At that time, when some Jews had taken down the icon of our Lord Jesus Christ, they said, 'As our fathers mocked Him once, let us also mock Him.' Then the assembled Jews began to spit in the face of Christ's icon and struck it in the face from one side and the other, saying, 'Whatever our fathers did to Him, let us do all the same to His image.' And they said, 'Because they mocked Him, let us also do the same.' With unrestrained ridicule they mocked the icon of Christ, as we do not dare even to tell in detail. Then they said, 'We have heard that they nailed His hands and feet; let us also do this to Him.' Then they pierced the hands and feet of the Lord's icon with nails. Again they said in their madness, 'We have heard that they gave Him with a sponge vinegar and gall to drink; let us also do the same.' And they did it, putting to the mouth of the Lord's icon the sponge filled with vinegar. Again they said, 'We have learned that our fathers struck His head with a reed; let us also do the same.' And taking a reed they struck at the head of the Master. Finally they said, 'As we learn accurately, that they pierced His side with a spear, let us omit nothing, but add this also.' And causing a spear to be brought, they assigned to one of their

number the task of raising the spear and stabbing through
the side of the Lord's icon. When this was done, at once
from the side of the icon there flowed a quantity of blood
and water."[25] Do you see the implications of what he says?
I refrain from speaking of the healings which came to those
who received the exudations from the side of the icon.

Heretic: They were Jews who saw that miracle. Signs are
for the unbelievers, not for the faithful.

20. *Orthodox:* I agree. But I have reported the story
because it shows that even if signs no longer occur, the
copy can still share the veneration of the prototype, as in
return the prototype shares the veneration of the copy, and
the veneration of both is one; as we have said in regard to
the life-giving cross and its representation. For recognition
of the symbol is also recognition of the life-giving cross,
just as denial of the symbol is denial of the life-giving cross.
The analogy will hold also for the icon of Christ and Christ
himself.

Heretic: That is all very well for the holy cross and its
symbol, but not for Christ and His image. Your illustration
is not appropriate, for icon should be compared to icon
and symbol to symbol.

21. *Orthodox:* We have spoken clearly enough al-
ready, sir, to require assent. Nevertheless, accept a little
question from me. Which is greater or more honorable,
Christ or the cross?

Heretic: The former, obviously, for by Christ the cross
was hallowed.

22. *Orthodox:* Is Christ's icon greater and more hon-
orable, or the symbol of the cross?

[25]Ps. Athanasius, *On the Passion of the Icon of Our Lord
Jesus Christ* (PG 28.814-15).

Heretic: It is not possible to doubt, for those who have any acquaintance with logic, that the copies differ in accordance with the differences of the prototypes; so the icon of Christ is more important than the symbol of the cross.

23. *Orthodox:* If that which is inferior and less honorable is correctly considered, it is stupid to say that the greater and more honorable is not also correctly considered. For what closer comparison does the icon of Christ have than the symbol of the cross, when the icon has the same relation with its prototype as the symbol has? We even speak figuratively of the icon of the life-giving cross, meaning its representation; and we speak of Christ's representation, meaning His icon. "Icon" etymologically comes from ἐοικός, which means "similar." Similarity is understood, named, and perceived both in the icon and in the symbol.

Heretic: Yes, I agree with this. Nevertheless you must compare icon with icon and symbol with symbol, even though you say that the former has the same meaning as the latter.

24. *Orthodox:* I have demonstrated this already quite clearly, if you paid attention, from the inspired fathers. But if you did not, let us here again listen to the holy Basil who enlightens our hearts. He says, "The image of the emperor is also called 'emperor,' yet there are not two emperors, nor is his power divided, nor his glory fragmented. Just as the power and authority which rules over us is one, so also the glorification which we offer is one, and not many. Therefore the honor given to the image passes over to the prototype."[26] What argument can deny that this example may be appropriately applied to Christ's icon? In the same way we must say that the icon of Christ is also called "Christ," and there are not two Christs; nor in

[26]*On the Holy Spirit* 18.45 (PG 32.149).

this case is the power divided, nor the glory fragmented. The honor given the image rightly passes over to the prototype.

Heretic: It would not have been right for the saint to apply the comparison of the emperor's image to the icon of Christ, but to Christ Himself the invisible icon, that is, the image of God the Father.[27]

25. *Orthodox:* So this is what you find remarkable, that the artificial image which was used by the saint as an analogy for the natural and unchangeable identity of the Father and the Son, this image is used by us not for the natural image of the Father but for the artificial image of Christ. Formerly the artificial image was compared with the natural, but now the artificial is compared with the artificial. How great the difference is! Nevertheless the saint, not finding any better comparison, used that of the emperor. How much more appropriately may we use the image of any earthly emperor in reference to the artificial image of Christ the true emperor! The image of the earthly emperor approaches more closely to the icon of Christ, as it is more preeminent in honor received from all his subjects; since he himself who rules on earth bears the image of Christ the true emperor because he bears the name of His glory. For the Scripture says, "Your dominion was given you from the Lord and your sovereignty from the Most High, who will search out your works and inquire into your plans, because as servants of His kingdom you did not rule rightly."[28]

Heretic: Although the divine Basil said that the honor given to the image passes over to the prototype, he was not speaking of the artificial, but of the natural image, namely

[27]Compare Col. 1.15. St. Basil was in fact speaking of Christ as the image of God the Father.

[28]Wisdom 6.5-6.

of the Son as image of the Father; and he spoke thus with good reason.

26. *Orthodox:* Stop, sir: because he did not say, "The image of the invisible Father is also called God, yet there are not two Gods" (which is true), but instead used the illustration of the emperor to support the theological doctrine, saying that the image of the emperor is also called "emperor," yet there are not two emperors, he implied the conclusion by consequence. Thus when he says, "The honor given to the image passes over to the prototype," he adds, "What here the image is by imitation, there the Son is by nature."[29] So he takes the relationship of the emperor to his image as a starting point, not the relationship of the Father to the Son. For he could have said the converse: "What here the Son is by nature, there the image is by imitation." Besides, the prototype and the copy seem to be things in our world; this applies also to Christ and His icon. For we confess that He became a man in our world, although He is also God. So it can be said in general about any kind of emperor, "The honor given to the image passes over to the prototype."

HONOR, VENERATION, AND HOLINESS

Heretic: But honor is not always understood as veneration by the inspired authors; for honor is one thing, and veneration is another.

27. *Orthodox:* How can you admit that between the prototype and the copy the power is not divided nor the glory fragmented, if you do not understand that both are

[29]*On the Holy Spirit* 18.45 (PG 32.149).

subject to one and the same veneration? Honor and veneration are similar to and inseparable from power and glory; the words are different because they are distinct names, but in effect they have the same force.

Heretic: He said that honor passes over, but not veneration. I too honor the icon of Christ, when it is placed up high; but I do not venerate it, as I have said.[30]

28. *Orthodox:* I have one question to begin with: on what authority do you honor the icon of Christ when it is placed up high? Basil did not say this, but said "honor" without qualification. So your contention has already collapsed. Secondly, how do you give honor without giving veneration, to something which is higher up or lower down? We indeed both honor and venerate the symbol of the life-giving cross, whether it is displayed up high or seen down low. In the secular sphere also, we honor the emperor whether he sits high up or appears low down, and likewise the general, the prefect, the master, or the teacher. But let us take the question to the divine Scriptures. What do you think, when it says, "Worthy art Thou, our Lord and holy God, to receive glory and honor and power"?[31] And again, "Worthy is the Lamb who was slain to receive power and wealth and wisdom and might and honor and glory and blessing."[32] And again, "To Him who sits upon the throne and to the Lamb be blessing and honor and glory and might unto ages of ages. Amen."[33] You see that in all of these passages, veneration is not mentioned anywhere. Shall we therefore, since it is not mentioned, deprive of veneration the Lamb who was slain, that is, our God and Savior? Or is it not obvious that all these pairs of syn-

[30]The emperor Leo V attempted a compromise in which icons would be allowed on higher walls and roofs of churches. See Every, p. 98.

[31]Rev. 4.11. [32]Rev. 5.12. [33]Rev. 5.13.

onyms are used in the same way? For he who is worthy of honor is also worthy of veneration; he who is worthy of power is also worthy of might; he who is worthy of blessing is also worthy of glory; and so also for whatever pairs of qualities are listed in the songs of praise. So if you refuse veneration to the image of the prototype, obviously you would also refuse honor and power and glory. But if one of these qualities is present, the others must also be effectively present.

Now I will throw another missile at you. "He who does not honor the Son," it is written, "does not honor the Father who sent Him."[34] What do you think? Does the honor which is offered to the Father and the Son exclude veneration? But this is foolish even to imagine. Again, when the God of all says through the prophet Isaiah, "Behold I am laying in Zion . . . an honorable cornerstone,"[35] because he does not add "venerable" shall we deny that the Son of God is venerable? And again the Scripture says, "Honor your father and your mother, that it may go well for you, and that your days may be long on the earth."[36] And again, "Whoever honors his father atones for sin, and whoever glorifies his mother is like one who lays up treasure."[37] So God does not command us here to venerate our parents, but only to honor them? This is very stupid. Again, the great apostle says, "Fear God; honor the emperor."[38] So then are we commanded merely to honor him, or also to venerate him? Who does not understand, if he has any sense? Besides, for my part, when I listen to the priest, I understand that honor and veneration belong to the same category and have the same force; for he says, "For unto Thee are due all glory, honor, and veneration."[39] Thus, therefore, when the divine Basil said, "The honor given to

[34]John 5.23.
[35]Is. 28.16.
[36]Ex. 20.12.

[37]Eccl. 3.3-4.
[38]1 Pet. 2.17.
[39]Liturgy of St. John Chrysostom.

the image passes over to the prototype," in silence he revealed also, in agreement with the blessed Athanasius, that the veneration given to the image passes over to the prototype.[40]

Heretic: Please prove your case by bringing together testimonies from various fathers, so that it may be more convincing to those who listen.

29. *Orthodox:* The blessed John, from whose lips flow the truly golden words, says this: "What therefore you have done for the names, you have also done for the image of that man. For on the bezels of rings, on cups and bottles, on the walls of rooms, and everywhere, many people have marked that holy image, so that they may not only hear that name but also see everywhere the representation of his body, and thus have a kind of double consolation for his absence."[41]

Heretic: And whose might this image be?

30. *Orthodox:* The image of Meletius the bishop of the Antiochians.

Heretic: He called the image "holy," but not "venerable." That which is holy is not necessarily venerable. For the holy apostle says, "The first tabernacle had regulations for worship and an earthly sanctuary. For a tent was prepared, the outer one, in which were the lampstand and the table and the presentation of the loaves; it is called the holy place. Behind the second curtain stood a tent called the holy of holies, having the golden altar of incense and the ark of the covenant covered on all sides with gold, which contained a golden urn holding the manna, and

[40]Basil, *On the Holy Spirit* 18.45 (PG 32.149); Athanasius, *Against the Arians* 3.5 (PG 26.332).

[41]John Chrysostom, *Homily on Bishop Meletius of Antioch* (PG 50.516).

Aaron's rod that budded, and the tables of the covenant; above it were the cherubim of glory overshadowing the mercy seat. Of these things we cannot now speak in detail."[42] The apostle has shown that the things which are called holy are certainly not also venerable.

31. *Orthodox:* When the apostle called these things holy, he also called them venerable by implication. However, the discussion of these matters must wait a little as it requires a rather long explanation. But answer one question for me. What do you say about the body and blood of our Lord Jesus Christ?

Heretic: They are holy, obviously, for the celebrant exclaims, "The holy things for the holy."[43]

32. *Orthodox:* Then do you also recognize that these things are venerable?

Heretic: Has anyone anywhere advanced so far in atheism as not to confess that these things are both holy and venerable?

33. *Orthodox:* Then are you not contradicting yourself, since you first said that the holy is not necessarily venerable, but now you deny what you affirmed?

Heretic: But then I was not talking about these holy mysteries, about which everyone agrees, as I said before.

34. *Orthodox:* What do you think about the Gospel, which is called holy: is it not also venerable? What about the symbol of the life-giving cross, and every sacred object?

Heretic: They are indeed holy, and also venerable. But the image of what is holy is far removed from their holiness. So although the icon is called holy, yet it is by no means venerable.

[42]Heb. 9.1-5. [43]Liturgy of St. John Chrysostom.

35. *Orthodox:* I also agree that the icon is far removed in holiness from those things, for they are called "holy of holies." Nevertheless every holy thing is venerable, although one is inferior to another in holiness and venerability. For that which is not at all venerable has no share at all in holiness either. You show me where anything is called holy which is not also venerable.

Heretic: I cited the apostolic words concerning those things which are called holy in the Law, to which you also have promised to return.

36. *Orthodox:* First I will say this, that whatever the Law says, it says to those under the Law. The ancient commandments should not be imposed on those under grace. If they were, we would keep the Sabbath, and be circumcised; many things contrary to our faith would follow. But we must understand these things only as a foreshadowing. The apostle says that the Law is a shadow but not the true image of the realities.[44] Secondly, we must prove that those things which are called holy in the Law are also venerable. If the cherubim are called glorious, and glory is similar to honor, and honor to veneration, clearly that which is holy is venerable, whether you like it or not.

Heretic: You have proved by artificial logic that what is holy is also venerable under the old covenant, but you have not proved it by indisputable witnesses.

37. *Orthodox:* Well, we shall hear from the leading fathers. Gregory the Theologian says somewhere in his works, "I know about Eli the priest, and Uzzah a little later. The former suffered punishment for the offense of his sons, which they committed against the sacrifices, by taking meat from the pot too soon; he suffered even though

[44]Heb. 10.1.

he did not condone their impiety, but often rebuked them. The latter, because he merely touched the ark when it was jostled by the ox, succeeded indeed in rescuing the ark, but perished himself, as God protected the holiness of the ark."[45] And later in the same work, he says, "So little did everyone walk boldly into the holy of holies, that only one man was permitted to enter once a year. So little did everyone look at or touch the veil, or the mercy seat, or the ark, or the cherubim."[46] Second, Basil the Great says that to the ark of the holy covenant things happened which had not even been heard of before; so that although the ark could not be touched by the Israelites or even by everyone of their priests, and could not be set down in every place, yet it was carried off by impious hands at different times in different places, and was deposited in temples of idols instead of the holy places.[47]

Heretic: It is true that the holy things are august, but the fathers do not say that they are venerable.

38. *Orthodox:* How could they be holy and august without having a share in veneration? The divine apostle says in the book of Acts, "As I passed along and observed your august monuments, I found also an altar with this inscription: 'To an unknown god.' "[48] Thus he implies that august things are also venerable. Besides, the emperor is called Augustus. For it is written, "When Paul had appealed to be kept in custody for the decision of Augustus . . ."[49] And a little later, "I found that he had done nothing deserving death; and as he himself appealed to Augustus, I decided to send him."[50] Do you understand that

[45]Or. 2.93 (PG 35.496) referring to 1 Sam. (1 Kings) 2.12-17, 2 Sam. (2 Kings) 6.6-7, 1 Chron. 13.9-10.

[46]Or. 2.94 (PG 35.497). [49]Acts 25.21.

[47]Reference unidentified. [50]Acts 25.25.

[48]Acts 17.23.

what is august is also venerable? No one in his right mind
would say that the emperor is august but not venerable.[51]

Moreover, the prohibition for anyone but the priest to
look at or touch the previously mentioned holy things shows
that according to Scripture they were set apart for honor.
If the ark of God performed signs and wonders on Uzzah
and on the foreigners who seized it, must it not have been
full of all glory, honor, and veneration, like the cherubim
and all the other things which the apostle mentions to-
gether? With this understanding the fathers of the Sixth
Ecumenical Council, in the sacred canons which they pub-
lished later, said the following: "In certain reproductions
of august images, the Precursor is pictured pointing to the
Lamb with his finger. This representation was adopted as
a symbol of grace. It was a hidden figure of that true Lamb
who is Christ our God, shown to us according to the Law.
Having thus welcomed these ancient figures and shadows
as symbols of the truth transmitted to the Church, we give
greater honor to grace and truth themselves, receiving them
as a fulfillment of the Law. Therefore, in order to expose
to the sight of all even in painting that which is perfect,
we decree that henceforth the Lamb who took away the
sin of the world, Christ our God, shall be represented in
His human form and not in the form of the ancient lamb.
We understand this to be the elevation of the humility of
God the Word, and we are led to remember His life in the
flesh, His passion, His saving death, and the deliverance
which came from it for the world."[52] You see that they
called the ancient types and shadows venerable, by using
the word "welcoming"; for to welcome is to venerate and
embrace.

[51]As a Byzantine, Theodore assimilates the pagan emperor
Augustus to the Christian emperors of later times.

[52]Canon 82, Quinisext Council (Mansi 11.977-980). See Ou-
spensky, p. 114f.

Likewise, Theodore the archbishop of Antioch, in his *Synodicon*, declares the same: "Against those who say in their heretical attacks that we should not venerate the artificial images of the saints, and who miscall them idols in their ignorance or rather impiety: they must know that the cherubim and the mercy seat, the ark and the rod, and the table which the prophet Moses made, were artificial things and were venerated. But the divine Scripture condemns those who venerate graven images."[53]

Heretic: Why then did Hezekiah smash the bronze serpent? For it is written, "He did what was right in the eyes of the Lord, according to all that David his father had done. He removed the high places, and broke the pillars, and cut down the groves, and broke the bronze serpent which Moses had made; because until those days the people of Israel had burned incense to it."[54]

39. *Orthodox:* For the same reason that the bronze serpent was not among the holy objects listed by the apostle. Concerning it Gregory the Theologian says, "The bronze serpent was hung up to protect against the biting serpents. It should not be understood as a type of Him who suffered for us, but as an antitype. It saves those who see it, not (we believe) because it is alive, but because it is dead and in its destruction rightly puts to death also the powers subject to it. And what funeral dirge should we sing for it? 'Where is your sting, O death? Where is your victory, O hell?' You have been wounded by the cross; you have been put to death by the giver of life. You are without breath, life, movement, or energy, though you preserve the form of a serpent raised up on high."[55] Rightly

[53]In fact Theodore of Jerusalem (745-67), whose *Synodicon* was read into the procedings of II Nicaea (Mansi 12.1135-46).

[54]4 Kings 18.34.

[55]Or. 45.22 (PG 36.653), 1 Cor. 15.55, Hos. 13.14.

it was destroyed when the Israelites offered incense to it;
for if the prototype does not deserve worship, the copy
must also be spurned. All the holy objects in the taber-
nacle, however, were prefigurations of the worship in the
Spirit, as the inspired Cyril proves.[56]

Heretic: I believe that this citation is apposite; but
since those whom you cited previously are recent, and not
among the ancient fathers, they cannot be accepted as
authoritative witnesses.

40. *Orthodox:* If what they say does not follow Basil
and the other inspired fathers, I do not accept them either,
nor does any of the orthodox. But if their words are con-
sistent and equivalent, not only those who are remembered
for speaking two hundred years ago, but also anyone up
to the present time who may say the same, should be both
accepted by the Church of God and numbered for his true
teaching with the holy apostles themselves, not merely with
the later inspired teachers. In this regard, listen to the
Acts of the Holy Confessor Maximus, where he says,
" 'Masters, since it has seemed good to do this, let your
decision be accomplished; and wherever you command,
I will follow you.' At these words everyone arose with tears
of joy, and they prostrated themselves and prayed. Each
of them kissed the holy Gospels, the honorable cross, and
the icons of our God and Savior Jesus Christ and of our
Lady the holy Theotokos who gave Him birth. They also
gave their hands to confirm what they had said."[57] I forbear
to say anything more because of the satiety of speech,
although there is a great swarm of texts available from
both ancient and recent authorities concerning the venerable
icons, if we had the leisure to unroll them all.

Heretic: I also have a swarm of texts from ancient and

[56]Reference unidentified.
[57]*Acts of St. Maximus the Confessor* 18 (PG 90.156).

recent authorities, but they are opposed to the erection and veneration of icons.

THE CIRCUMSCRIPTION OF THE RISEN CHRIST

41. *Orthodox:* If your opposition were aiming to prevent the erection of the icon of our Lord Jesus Christ, you could bring forth such texts. But since you have accepted the depiction and deny only the veneration, why do you again totter and stumble from one position to another, as liars are wont to do?

Heretic: Admittedly it is agreed that our Lord Jesus Christ is circumscribed, but only up to His passion, and by no means after His resurrection. For the apostle says, "Even though we once knew Christ according to the flesh, yet now we know Him thus no longer."[58] And likewise Gregory the Theologian says, "He is perfect not only by His divinity, than which nothing is more perfect, but also by His assumed flesh, which is anointed with divinity, and has become that which anoints it and even (if I may be so bold) the same as God."[59] If the assumed flesh is the same as God, how could it be circumscribed while being united with the imperishable divinity?

42. *Orthodox:* Nevertheless you have conceded that Christ is circumscribed before His passion, and is venerated in the circumscription of such an icon.

Heretic: Even if I should concede as much, and not object, where does your argument lead?

43. *Orthodox:* That the authorities which you have

[58]2 Cor. 5.16.
[59]Gregory the Theologian, Or. 45 (On Pascha; PG 36.640-41).

previously introduced do not show that it was possible for
Christ to be circumscribed either before His passion or
after His resurrection. In particular they do not say that
although He is circumscribed, His image remains high up
and is not venerated. Why do you bring in as your sup-
porters those who oppose you in half your position? It is
time for you to look for other authorities who agree com-
pletely with your argument. But in fact, Christ is circum-
scribed even after His resurrection. Listen to Him speaking
to His own disciples, when after the resurrection they
thought they saw Him as a spirit: "See my hands and feet,
that it is I myself."[60] If then He said that He whom they
saw after the resurrection was that same one who was with
them before the passion, obviously just as He was circum-
scribed before the passion, after the resurrection also He
was contained by circumscription, because He had not
lost the properties of His human nature. What kind of
hands and feet did He show them, sir? How did He bid
them to touch Him, as a man with flesh and bones? What
kind of food did He taste? Must not one who has these
properties either be circumscribed, or if he is no circum-
scribed, be a ghost, as He seemed at that time to the
apostles?

Heretic: But although Christ is said to have these prop-
erties, certainly He does not have them as we do; and for
this reason He is not circumscribable.

44. *Orthodox:* Then if He does not have these prop-
erties as we do, neither do you believe that He became
like us. But if the second is true, must not the first be
believed? Or perhaps you think that the names of members
are used figuratively to indicate some kind of energies in
Christ, and not for the truth of the realities? That is how
such words are understood in theology; for example, the

[60]Luke 24.39.

divine Basil says, "There are many human characteristics, yet we do not therefore understand God to be a man. . . . When you hear 'the hands of God,' understand His creative power; when you hear 'ears,' His power of hearing; when you hear 'eyes,' His power of sight; when you hear 'wings,' His protective power; and so forth."[61] For the rest, if this is how you think, it must be that you believe that our Lord Jesus Christ did not become man. If He did become man (which is true), then you must believe that He truly had flesh and bones even after His resurrection.

Heretic: Using the means of condescension the Lord showed Himself to His apostles after His resurrection. He had the properties of the body, but without solidity or circumscription. Thus He appeared in the midst of them although the doors were closed, and again He disappeared from them.

45. *Orthodox:* If you assert that Christ is not circumscribed because He is without solidity after His resurrection, you must assert also that He was not seen by His apostles. But if He is seen, He is circumscribed. Everything which is subject to vision must also be subject to circumscription: all the more that which has hands and feet, flesh and bones, which is touched and shares food.

Heretic: The apostles beheld the Lord with purified eyes; we are not able to look upon Him with eyes like theirs.

46. *Orthodox:* But what does the Lord say to Thomas? "Because you have seen me, you have believed. Blessed are those who have not seen, and yet believe."[62] Therefore, as the apostles saw and reported, both before the passion and after the resurrection, so we have received the tradi-

[61]*Against Eunomius* 5 (PG 29.757).
[62]John 20.29.

tion, and so we circumscribe Christ. For they did not say
to us that it is not possible for us to see with such eyes as
they used; although even before the passion, when they
were about to sink in the boat, suddenly Christ appeared
walking on the sea: a phenomenon uncharacteristic of
human nature, that unstable water, as the divine Diony-
sius says,[63] supported the weight of material and earthly
feet and did not yield, but held together by a supernatural
power as if it were solid. Nevertheless when He wished
He revealed His supernatural powers before His passion.
What power was not available to Him if He had wished?
Thus also after the resurrection, although He was without
solidity, when He wished He showed properties as if He
were solid. He was seen and touched, and He shared food:
these are properties of evident circumscription.

Heretic: How should we understand the apostolic say-
ing, "Even though we once knew Christ according to the
flesh, yet now we know Him thus no longer"?[64]

47. *Orthodox:* In the first place, we learn from the
apostle himself that we are members of one body with
Christ and fellow partakers of Him;[65] and we certainly do
not cease to be subject to circumscription because we are
accounted worthy of such grace. For if, as you say, Christ
were uncircumscribed after His resurrection, we also who
are one body with Him would have to be uncircumscribed.
In the same way as identity with God, concorporeality
must be understood in view of a relationship. It does not
follow from Christ's identity with God that He is uncir-
cumscribed, as it does not follow from our concorporeality
with Christ that we are uncircumscribed.

Secondly, listen to Gregory the Theologian, who says,

[63]*Divine Names* 2.9 (PG 3.648).
[64]2 Cor. 5.16.
[65]Eph. 3.6; 1 Cor. 10.16, 12.12.

" 'For one is God and the mediator between God and mankind, the man Jesus Christ.'[66] Even now He intercedes as man for my salvation, because He is with the body which He assumed in order to deify me by the power of His hominization, even though He is no longer known according to the flesh (that is, with the sufferings of the flesh, which are the same as ours except for sin)."[67] Do you see that He is now with the body which He assumed? And as for not being known according to the flesh, do you see that that means according to the sufferings of the flesh (except for sin), and that it does not imply uncircumscribability, as you suppose? For Gregory says, "Circumscribed in the body, uncircumscribed in the spirit,"[68] not referring to a limited time, but speaking absolutely for all time. Elsewhere he says this: "How could He be touched after His resurrection, and how will He be seen by those who have pierced Him?[69] Godhead in itself is invisible. But He will come with His body, as I judge; but such as He was seen by His disciples on the mountain, and was revealed with His divinity overwhelming His flesh, for indeed His divinity was thus revealed before His resurrection."[70]

PATRISTIC AUTHORITY FOR ICONOCLASM

Heretic: What if I bring forward more authoritative texts from the holy fathers? How would you refute them, when they utterly forbid the erection of an image of the Lord or the Theotokos or any other of the saints?

48. *Orthodox:* The texts are not from saintly fathers

[66]1 Tim. 2.5.
[67]Or. 30.14 (PG 36.121).
[68]Ep. 101 (PG 37.177).

[69]John 19.37.
[70]Ep. 101 (PG 37.181).

but from heretical interpolators; otherwise they would agree with the inspired fathers.

Heretic: Epiphanius is one of them, the man who is prominent and renowned among the saints.

49. *Orthodox:* We know that Epiphanius is a saint and a great wonder-worker. Sabinus, his disciple and a member of his household, erected a church in his honor after his death, and had it decorated with pictures of all the Gospel stories. He would not have done this if he had not been following the doctrine of his own teacher. Leontius also, the interpreter of the divine Epiphanius' writings, who was himself bishop of the church of Neapolis in Cyprus, teaches very clearly in his discourse on Epiphanius how steadfast he was in regard to the holy icons, and reports nothing derogatory concerning him. So the composition against the icons is spurious and not at all the work of the divine Epiphanius.[71] Nevertheless listen to Basil the Great in this connection: "As for me, not only will I not yield so as to retreat one step if anyone who has received a letter from men gives himself airs because of it: not even if it comes from the very heavens, but does not agree with the healthful word of the faith, am I able to judge that he has a share with the saints."[72]

And listen to the golden-voiced preacher, when he says that the divine Paul does not respect the dignity of persons when the truth is at issue. Or rather let us listen to Paul himself, who exclaims, "But even if we, or an angel from heaven, should preach to you a gospel contrary to that which you received, let him be accursed."[73] For evidence, moreover, that we have received from the apostles them-

[71]Epiphanius of Salamis. The authenticity of a treatise against the veneration of images ascribed to him is still disputed; see Ouspensky, p. 157, Pelikan 2, p. 102.

[72]Reference unidentified. [73]Gal. 1.8-9.

selves and have preserved up to the present time the tradition of erecting the icon of our Lord Jesus Christ, of the Theotokos, and of any of the saints—raise your eyes, look around, and see everywhere under heaven, throughout the sacred edifices and the holy monuments in them, these images depicted and necessarily venerated in the places where they are depicted. Even if there were no dogmatic reason nor voices of inspired fathers to uphold both the erection and the veneration of icons, the prevailing ancient tradition would be sufficient for confirmation of the truth. Who can presume to oppose this tradition? By his opposition he falls away far from God and the sheepfold of Christ, because he thinks like the Manicheans and the Valentinians, who babbled heretically that God had dwelt among those on earth only in appearance and fantasy.

Third Refutation of
The Iconoclasts

David the psalmist is celebrated for striking down Goliath the foreigner with one cast of a stone from his slingshot. I, however, as I am unskilled in war, am now throwing this third cast of argument after the first two in hope of destroying the foreign thinking of the iconoclasts, although the attempt may be beyond my strength. I shall use some syllogisms to present the subject of my treatise, not indeed with the technical artifice of the Aristotelian system (or rather silliness), but with a simpler form of expression, relying on the might of truth. Perhaps this effort may not be unprofitable to those who use it: if they are wise, it may provide a start for wiser consideration; but if they are unlearned, it may give a kind of introduction to assist the correct understanding, which is now hard-pressed by the attack of the iconoclast heresy. And since a clear division is helpful to the reader, I shall arrange the treatise in four chapters, marshalling under each heading the arguments which aim at the same target.

A. The portrayal of Christ in the body.

B. Because Christ is circumscribed, He has an artificial image, in which He is contemplated, as it is also in Him.

C. There is one indivisible veneration of Christ and His image.

D. Since Christ is the prototype of His own image, He has one likeness as He has one veneration with it.

A. The portrayal of Christ in the body.

1. Common ideas are those accepted by everyone equally: for example, that when the sun is above the earth, it is day and not night; or, if something is animate, rational, mortal, and capable of thought and understanding, it is a human being; or, every three-dimensional body, having a firm surface, that can be seen and touched, is circumscribed. So what do you think, gentlemen? Is this the kind of body which the Word of the Father received when He became man? If they say yes, then they must undoubtedly agree that it is circumscribed. But if they say no, that is no different from saying that when the sun is above the earth it is not day but night; and that if something is animate, rational, mortal, and capable of thought and understanding, it is not a human being. Only madmen think and speak this way. Only fools debate with madmen. Therefore we are not addressing those who voluntarily deafen themselves, but those who have ears to hear.

2. Sight precedes hearing both in the location of its organs and in the perception by the senses. For one first sees something and then transmits the sight to the sense of hearing. For example, Isaiah saw the Lord sitting on the throne of glory, surrounded and praised by the six-winged seraphim.[1] Likewise Ezekiel gazed upon the chariot of God, the cherubim.[2] Moreover, even the divine-voiced disciples first saw the Lord and later wrote out the message. If, therefore, this is how it is, and however far you go back, you would find the written word originating in observation, then it is undoubtedly necessary that if the sight of Christ is removed, the written word about Him must be removed first; and if the second is sketched out, the first must be sketched beforehand.

[1] Is. 6.1. [2] Ezek. 1.10.

3. If uncircumscribability is characteristic of God's essence, and circumscription is characteristic of man's essence, but Christ is from both: then He is made known in two properties, as in two natures.[3] How would it not be blasphemous to say that He is uncircumscribed in body as well as in spirit, since if His circumscription were removed His human nature would be removed also?

4. If things do not have the same properties, then their essences are different. It is proper to divinity to be uncircumscribable, bodiless, and formless. It is proper to humanity to be circumscribed, tangible, and three-dimensional. If, therefore, Christ is from both essences, He must be both uncircumscribable and circumscribed. If He is only one or the other, He is of only the one essence of which He has the property—which is heretical.

5. If the circumscription is eliminated by the uncircumscribability, as if it were not possible for one and the other to be in Christ: then it must also be true that the tangibility is eliminated by the intangibility, and whatever other opposed properties belong to His two natures. If this is heretical, then it would also be heretical to say that He is not circumscribed in respect to His incarnation.

6. If Christ cannot be circumscribed, neither can He suffer; for impassibility is equivalent to uncircumscribability. But He is able to suffer, as the Scriptures say. Therefore He is also circumscribable.

7. *The passage, "The Lord created me at the beginning of His work, the first of His acts of old. . . . Before*

[3]The doctrine of Christ's two natures was proclaimed by the council of Chalcedon in 451.

the hills, I was brought forth,"[4] *reveals the two natures*
of Christ, the uncircumscribable and the circumscribed.

If the first verse, "The Lord created me at the begin-
ning of His work, the first of His works of old," refers to
humanity, but the later verse, "Before the hills, I was
brought forth," refers to divinity: then the speaker must
be subject to circumscription insofar as He is created; but
insofar as He is uncreated, He must be uncircumscribable.
But if, because He is circumscribed in one nature (the
created), the other nature (the uncreated) should also be
circumscribed: then the one must change from uncircum-
scribable to circumscribed, and the other from circum-
scribed to uncircumscribable. Each nature must exchange
with the other its own character, and lose the natural and
inalienable property which belongs to it; and in sum neither
remains truly itself because of the vain alternation—which
is absurd.

8. If by the saying, "The Lord created me at the
beginning of His work," we understand not that the Word
has been changed into flesh because of the combination of
divinity and humanity in Him, but that the Word has
become flesh while remaining on the height of His divinity:
in the same manner, when we say that He is also circum-
scribed, we do not believe that He is changed into circum-
scription, insofar as He is God, but that insofar as He
has become man, He appears like us. But if in being
circumscribed the uncircumscribability is changed, then
also in becoming flesh the nature of divinity is changed—
which is absurd.

9. Saying, "The Lord created me," is equivalent to
saying, "The Lord circumscribed me." For if it is not
possible to say, merely because it is not written, "The Lord

[4]Prov. 8.22, 25.

made me," or "The Lord embodied me," that these things did not happen to Him, so because it is written, "The Lord created me," it is possible for those who wish to think correctly to understand equally, "He also circumscribed me." For creation is a property of circumscription, as those know who have even a little intelligence.

10. If Christ is uncircumscribable, as you say, not only in respect to His divinity, but also in respect to His humanity, then His humanity is also divinity. For things which have the same properties also have one nature. But if He is of two natures, He is therefore also of two properties: otherwise, by the removal of circumscription, the nature of humanity would also be removed.

11. If every image is an image of form, shape, or appearance and of color, and if Christ has all these, since the Scriptures say, "He took the form of a servant . . . and was found in human shape,"[5] and had an "ignoble and inferior" appearance,[6] which signifies the body: then He is portrayed in just such a circumscription in His likeness.

12. Just as uncircumscribability, intangibility, and formlessness are of the same order, so are circumscription, tangibility, formedness, and whatever other properties are opposed to each other. If, therefore, Christ is uncircumscribable as man, in consequence we would have to say that He is intangible and formless: for both are of the same order. But if this is absurd, and if one property cannot be separated from the other (just as uncircumscribability cannot be separated from intangibility and formlessness), then if He is tangible He must also be circumscribable: otherwise because of His uncircumscribability we should admit that He is also intangible—which is heretical.

[5]Phil. 2.7. [6]Is. 53.3 LXX.

13. There are many kinds of circumscription—inclusion, quantity, quality, position, places, times, shapes, bodies—all of which are denied in the case of God, for divinity has none of these. But Christ incarnate is revealed within these limitations. For He who is uncontainable was contained in the Virgin's womb; He who is measureless became three cubits tall; He who has no quality was formed in a certain quality; He who has no position stood, sat, and lay down; He who is timeless became twelve years old by increasing in age; He who is formless appeared in the form of a man; He who is bodiless, when He had assumed a body, said to His disciples, "Take, eat, this is my body."[7] Therefore the same one is circumscribed and uncircumscribable, the latter in His divinity and the former in His humanity—even if the impious iconoclasts do not like it.

14. If "no one has ever seen God," as the Father's only-begotten Son, who is Himself God, has made Him known,[8] how can He say to the blind man who has received his sight, "You have seen Him, and it is He who speaks with you"?[9] So we must infer that the same one is visible and invisible: invisible according to His uncircumscribable nature (for that which is uncircumscribable is invisible), but visible according to His circumscribed humanity (for that which is circumscribed is visible). This inference is true.

15. *An objection as from the iconoclasts:* "If Christ miraculously assumed flesh in His own hypostasis, but flesh without distinguishing features because it does not indicate a particular man but rather man in general:[10] how then is it possible for this flesh to be found tangible and to be

[7]I Cor. 11.24. [9]John 9.37.
[8]John 1.18. [10]See *First Refutation,* note 10.

portrayed in various colors? The argument is vain and the idea is false."

Answer: If Christ miraculously assumed flesh in His own hypostasis, but flesh without distinguishing features (as you say) because it does not indicate a particular man but rather man in general: how did He subsist in it? Generalities have their existence in particular individuals: for example, humanity in Peter and Paul and the others of the same species. If the particular individuals did not exist, man in general would be eliminated. Therefore humanity is not in Christ, if it does not subsist in Him as in an individual; and in that case we would have to say that He became incarnate in fantasy, and could not be touched or circumscribed with various colors. But this is the Manichaeans' idea.

16. Generalities are seen with the mind and thought; particular individuals are seen with the eyes, which look at perceptible things. If, therefore, Christ assumed our nature in general, not contemplated in an individual manner, He can be contemplated only by the mind and touched only by thought. But He says to Thomas, "Because you have seen me, you have believed; blessed are those who have not seen and yet believe."[11] And He also says, "Put your finger here, and see my hands; and put out your hand, and place it in my side";[12] thus He associates perceptible things with perceptible things. So Christ is perceptible, tangible, and visible with bodily eyes; and therefore He is circumscribed.

17. When I say "man," I mean the common essence. When I add "a," I mean the hypostasis: that is, the self-subsisting existence of that which is signified, and (so to speak) the circumscription consisting of certain properties,

[11]John 20.29. [12]John 20.27.

by which those who share the same nature differ one from
another, for example Peter and Paul. When Christ said
to the Jews, "Now you seek to kill me,"[13] if He had said
simply "man," He could have meant man in general. But
when He added, "a man who has told you the truth," He
revealed His own hypostasis or person. For the relative
pronoun "who" has the same effect as the article "a."[14]
Therefore, although He assumed human nature in general,
yet He assumed it as contemplated in an individual man-
ner; for this reason the possibility of circumscription exists.

18. "Man" in general is a common noun; but the
particular name, such as "Peter" or "Paul," is a proper
noun. The particular individual can be called by the com-
mon name as well as by the proper name. For example,
Paul is also called "man": in respect to what he shares with
the individuals of the same species, he is called "man"; but
insofar as he differs in his hypostasis, he is called "Paul."
If, therefore, Christ were called simply "God" and "man"
in the Scripture, then He would have assumed simply our
nature in general (which, as we have previously demon-
strated, cannot even subsist if it is not contemplated in an
individual manner). However, Gabriel said to the Virgin,
"Behold, you will conceive in your womb and bear a son,
and you shall call His name Jesus."[15] So Christ is called
not only by a common noun but also by a proper name:
this separates Him by His hypostatic properties from the
rest of men, and because of this He is circumscribable.

19. If Christ does not represent an individual, as you
say, but man in general, how can He say to His disciples,

[13]John 8.40.

[14]That is, either the indefinite article or the relative clause
makes the noun "man" refer to a particular individual.

[15]Luke 1.31.

"Who do men say that I, the son of man, am?"[16] There-
fore He is one like us, although He is God and one of the
Trinity. Just as He is distinguished from the Father and
the Spirit by the property of sonship, so He is differenti-
ated from all other men by His hypostatic properties; and
because of this He is circumscribed.

20. If Christ does not represent an individual, as you
say, but man in general, how can He say to the Jews,
" 'Whom do you seek?' They answered Him, 'Jesus of
Nazareth.' Jesus said to them, 'I am He.' "[17] Therefore
Christ is an individual, as He is called by a proper name,
"Jesus of Nazareth." But if He is an individual, then He
is also circumscribed, as He is characterized by His hypo-
static properties.

21. Members of the same species are one in essence
but hypostatically differentiated one from another: there
is this one and there is that one. If, therefore, Christ does
not represent an individual, but man in general, as you say,
He would not be distinguished from another person. So
how could He say to Peter, "Then the sons are free. How-
ever, not to give offense to them, go to the sea and cast a
hook, and take the first fish that comes up, and when you
open its mouth you will find a shekel; take that and give
it to them for me and for yourself"?[18] Therefore, because
He is distinguished from Peter, and pays the two drachmas
equally with him, He must equally be circumscribed, as
representing an individual, although He assumed human
nature in general.

22. *Objection as from the iconoclasts:* "If the Word
assumed human nature in His own hypostasis, since this
nature is invisible and formless, if it should be given form

[16]Matt. 16.13. [17]John 18.4-5. [18]Matt. 17.26-27.

by circumscription, a second person will be admitted in the hypostasis of Christ—but this is absurd, and is allied to the heresy of Nestorius, to preach a duality of persons in Christ."[19]

Answer: If we said that the flesh assumed by the Word had its own hypostasis, your argument would be plausible. But since, according to the Church's judgment, we confess that the hypostasis of the Word became a common hypostasis of the two natures, hypostasizing the human nature in it, with the properties which differentiate it from the others of the same species, we may with reason say that the same hypostasis of the Word is uncircumscribable according to the nature of His divinity but circumscribed according to His essence like ours. This human nature does not have its existence in a self-subsisting and self-circumscribed person, apart from the hypostasis of the Word, but has its existence in that hypostasis (lest there should be a nature without hypostasis), and in it is contemplated in an individual manner and is circumscribed.

23. If, because a second person is not admitted in the hypostasis of Christ, they should say that the hypostasis is uncircumscribable in respect to its humanity, they must necessarily say that there is one nature of the Word compounded from two natures, and therefore uncircumscribed, because the property of one of the two natures has been eliminated—which is related to the opinion of the Acephaloi and Apollinarius.[20]

24. If, because a second person is not admitted in

[19]The Nestorians believe that Christ has two natures, two hypostases, but one person. See Pelikan 2, p. 43. In orthodox usage, "hypostasis" and "person" are practically synonymous.

[20]The Apollinarists seemed to deny that Christ had a human soul; the Acephaloi (or monophysites) argued that He had but one nature, the divine. See Pelikan 2, p. 27.

the hypostasis of Christ, they should say that the hypostasis is uncircumscribable in respect to its humanity: He would not have assumed this humanity in truth, but only in the likeness and form of flesh, which is the Montanists' teaching.[21] But if He assumed humanity in truth, as we confess, then the hypostasis of Christ is circumscribable: not according to its divinity, which no one has ever beheld, but according to the humanity which is contemplated in an individual manner in it. For how could one be the mediator of God and mankind[22] if He did not preserve intact the properties of both natures from which He consists?

25. "Where" signifies the place by which a body is contained. Not only the body is circumscribed, but also the place which contains it. Only that which is without any location is uncircumscribable, as it is limitless. If, therefore, Christ is not circumscribable, not only is He not a body, but also He is without location; and how can He himself say, "The bread which I shall give . . . is my flesh"?[23] Or again, when Andrew and the other disciple asked, "Where are You staying?" He answered, "Come and see." And the evangelist continues, "They came and saw where He was staying."[24] Therefore He is circumscribed, as He has assumed a body, whether He remains at home, returns home, or leaves home.

26. *An apparent contradiction, suggesting that Christ is not circumscribed, because the Scripture says, "You heard the sound of words, but saw no form; there was only a voice."*[25] If Moses says, speaking about the God of all, "You heard the sound of words, but saw no form; there was only a voice," and Isaiah on the other hand

[21]On docetic movements, see *First Refutation,* note 11.
[22]I Tim. 2.5. [24]John 1.38-39.
[23]John 6.51. [25]Deut. 4.12.

says, "We saw Him, and He had no form or beauty; but His appearance was ignoble, and inferior to all the children of men,"[26] how will these prophets agree with each other, if indeed one does not conflict with the other? Clearly both are speaking about the same one. Moses is denying that the Godhead can be in a likeness, for divinity is invisible, and therefore unlike anything. Isaiah is affirming, in reference to the same Lord who took the form of a servant, that He is seen in an appearance like ours. Therefore Christ is circumscribed in body, though uncircumscribable in divinity.

27. If Christ is uncircumscribable, yet Isaiah says about Him, "a man who suffered blows and was acquainted with the bearing of sickness,"[27] I ask, is that which receives a blow a body or something bodiless? And if it is bodiless, it is a ghostly appearance; but if it is a body, how can it avoid being something circumscribed, characterized by three dimensions and a firm surface, which is naturally able to be wounded?

28. If Christ is not circumscribable, how can He Himself say, "I gave my back to the smiters, and my cheeks to those who pulled out the beard; I hid not my face from shame and spitting"?[28] These are properties of circumscription: a smitten back, cheeks with the beard pulled out, a face spat upon. Therefore if the Sufferer speaks the truth, the man is lying who says that He is not circumscribed.

29. If Christ is uncircumscribable, how can He Himself say, "They have pierced my hands and my feet; they have numbered all my bones"?[29] For that which is uncircumscribable does not have a nature to be pierced, nor to

[26]Is. 53.3. [28]Is. 50.6.
[27]Is. 53.3 [29]Ps. 21 (22).16-17.

have its bones numbered. To believe these words is to confess the circumscription.

30. A line is a length with no width, bounded by two points, from which a drawing begins. A figure is that which consists of at least three lines. From it begins a body, which is formed from different figures and is bounded by a place. But that which is uncircumscribable is unlike these, and is not bounded even by a line, much less a figure or a place or a body. Therefore, if Christ is uncircumscribable, He will be found neither in a figure, nor in a place, not to mention in a body. But He was found in a figure, as a man, according to the Scripture;[30] and He was circumscribed by a place, living in Nazareth;[31] and He became flesh, as the evangelist says;[32] therefore He is also circumscribed.

31. If Christ is uncircumscribable, how can the Forerunner say, "See the Lamb of God who takes away the sin of the world"?[33] For that which is seen is not uncircumscribable, not to mention that which is pointed out with the finger. But if something should be seen and pointed out, then it would be within circumscription, as if marked out by the finger. Therefore Christ is circumscribable.

32. If Christ is not circumscribable, He is not of two natures, divinity and humanity, since He does not have the property of each. For circumscribability is characteristic of humanity. But if He is of two natures, how can He avoid having the properties of those whose natures He has?

[30]Phil. 2.7. [32]John 1.14.
[31]Matt. 2.23. [33]John 1.29.

33. If it is heretical to say that, because Christ is crucified in the flesh, the Godhead also suffers (for that is the teaching of the Theopaschites[34]): then likewise it is heretical to say that, because He is circumscribed in the flesh, the Godhead is also circumscribed (for this is the teaching of the iconoclasts). And this heresy is the more impious, as the flesh is joined with the Godhead in a union of natures, while the depicted shadow has only a relation to the flesh.

34. *An objection as from the iconoclasts:* "If Christ is of two natures, when you claim to portray Him why do you not portray both natures from which and in which He is, if you are speaking the truth?[35] But since one of the two is falsified, because the human circumscription does not contain the uncircumscribability of the divine nature, it is heretical to circumscribe Christ."

Answer: When anyone is portrayed, it is not the nature but the hypostasis which is portrayed. For how could a nature be portrayed unless it were contemplated in a hypostasis? For example, Peter is not portrayed insofar as he is animate, rational, mortal, and capable of thought and understanding; for this does not define Peter only, but also Paul and John, and all those of the same species. But insofar as he adds along with the common definition certain properties, such as a long or short nose, curly hair, a good complexion, bright eyes, or whatever else characterizes his particular appearance, he is distinguished from the other individuals of the same species. Moreover, although he consists of body and soul, he does not show the property of soul in the appearance of his form: how could he, since

[34]Although the hypostasis of Christ suffered, His divine nature could not suffer. See Pelikan 2, p. 83.

[35]The iconoclastic council of 754 claimed that Christ could not be portrayed without separating His two natures; hence the iconodules would be guilty of Nestorianism. See Pelikan 2, p. 116.

the soul is invisible? The same applies to the case of Christ. It is not because He is man simply (along with being God) that He is able to be portrayed; but because He is differentiated from all others of the same species by His hypostatic properties. He is crucified and has a certain appearance. Therefore Christ is circumscribed in respect to His hypostasis, though uncircumscribable in His divinity; but the natures of which He is composed are not circumscribed.

35. If Christ is not circumscribed, as you say, because He would be diminished in glory, then He was not conceived in the Virgin's womb either, because He would have endured humiliation. But if He was not only conceived without humiliation, but even born as an infant, then He is circumscribed without shame.

36. Every moving creature is not the species as defined in general (for this is invisible, formless, and shapeless, and therefore uncircumscribable), but is rather the individual which naturally consists of properties. This individual is seen, moves, and speaks, and therefore is circumscribed, for example James or John. If, therefore, Christ is uncircumscribable, He is not seen, He does not move or speak with an articulate voice, does not have tongue or lips, does not eat or drink, sleep or wake, or anything else which everyone does or endures. But if we confess that He did these things, how can He not be circumscribed, unless the mystery of the divine economy is a fantasy?

37. If things which are of different kinds and not of the same essence have different properties corresponding to their essences, and in particular this is true of divinity and humanity: how can it be that Christ, who is from both, is not in both, if indeed every essence is distinguished from all the others by its own property? But if He is in

both, then the same one is both circumscribed and un-circumscribable.

38. The true properties of the essences make known the essences of which they are properties: uncircumscriba-bility makes divinity known. Therefore if Christ is from both, then He is also circumscribed as well as uncircum-scribable. But if He is not circumscribed, neither is He truly man as well as truly God. But He is truly man, and therefore truly circumscribed.

39. *An objection as from the iconoclasts:* "If the Son is the perfect image of the Father, so that the Father ap-pears in Him, as the Scripture says, 'He who has seen me has seen the Father,'[36] we must say that He who comes from the uncircumscribable Father is uncircumscribable. For how could that which is uncircumscribable even be seen in that which is circumscribed? Therefore Christ is uncircumscribable."

Answer: If He who comes from the uncircumscribable Father is uncircumscribable, then obviously He who comes from a circumscribed mother is circumscribed—unless we are to understand that the begetting is true but the birth false. But if both are true of the one Christ, then He has also acquired the properties of both origins, and is uncir-cumscribable and circumscribed.

40. If the archetype appears in the image, let us suppose that the archetype is in all respects like the image. But Christ is embodied. Then the Father, upon whom the image is modeled, must also be embodied. But if this is absurd, let us say that Christ is altogether uncircumscrib-able, as the image of the Father; for the Father is un-circumscribable, because He is also bodiless. But according

[36]John 14.9.

to what Christ Himself said, that He is the son of man, (do not be surprised at this) we must say that He is circumscribed; for every man is circumscribed, because he is also embodied. This is the truth.

41. If it was in reference to His bodily appearance, as you say, that Christ said, "He who has seen me has seen the Father,"[37] then He must necessarily have by nature all those qualities which the Father has; for thus the imprint is accurate. But the Father is formless, shapeless, uncircumscribable; so Christ must be the same. For how could formlessness appear in one who has received a form, or shapelessness in one who has been given shape, or uncircumscribability in one who is circumscribed? But if this is heretical, then it would also be heretical to say that Christ is speaking of His bodily appearance when He says, "He who has seen me has seen the Father." The remaining alternative is to say that He is speaking of the form of divinity; and this is true.

42. *An objection as from the iconoclasts:* "If Christ were a mere man," they say, "He would be circumscribable; for circumscription is characteristic of a mere man. But since He is not a mere man (for He is both God and man),[38] He is not circumscribable either."

Answer: If, in denying that Christ is a mere man, they should say that He is uncircumscribable, they must also say that He is bodiless. It is because a thing is circumscribed and has form that it is recognizable as being a body. If these qualities are lacking, then we must also deny that to which they belong. But Christ has a body and a form, and therefore He also has circumscription.

43. If, because Christ is not a mere man, they should

[37]John 14.9. [38]Compare *Ref.* 1.4.

say that He is uncircumscribable in respect to His human-
ity: since this is a property of His divine nature, immiscible
things would be mixed, namely circumscription in uncir-
cumscribability. If the properties of things are mixed, then
obviously their natures are mixed also. But if this is hereti-
cal to say or think, then Christ is not a mere man although
He is circumscribed in a body—otherwise, in consequence
of His circumscription, immiscible things would be mixed.

44. That which is uncircumscribable is simple and
not composite, because it is exempt from any kind of
position or composition. But Christ, who is double and
composite, if He were not circumscribed, would lose the
form and fact of doubleness and composition. But we con-
fess that He is double and composite, and therefore that He
is circumscribed. This confession is true.

45. Maleness and femaleness are sought only in the
forms of bodies, since none of the differences which char-
acterize the sexes can be recognized in bodiless beings.
Therefore, if Christ were uncircumscribable, as being with-
out a body, He would also be without the difference of
sex. But He was born male, as Isaiah says, from "the
prophetess":[39] therefore He is circumscribed.

46. Some bodies can be cut only in thought, namely
those which are intangible and therefore uncircumscribable;
other bodies can be cut in actuality, namely those which
are solid as they are tangible, and therefore circumscribed.
If, therefore, Christ has assumed a body that cannot be
cut, then it is also uncircumscribable. But His body can
be cut in fact; for the evangelist Luke says, "And at the
end of eight days, when He was circumcised . . ."[40] If He

[39]Is. 8.3. Isaiah's son is understood as a type of Christ; compare
Is. 8.18. [40]Luke 2.21.

was circumcised, then he is circumscribed—which is true.

47. *An objection as from the iconoclasts:* "If whatever bodies cannot be cut or touched are also uncircumscribable, since the angels are bodiless, how can they be subject to circumscription? Therefore if they are circumscribed they are also embodied. But if they are bodiless, then they are not circumscribable."

Answer: By comparison with a dense body, the nature of angels is bodiless; but by comparison with divinity, their nature is neither bodiless nor uncircumscribable. For this reason the apostle says, "There are celestial bodies and there are terrestrial bodies."[41] That which is properly called bodiless is boundless and uncircumscribable: this applies only to the divine nature. But an angel is bounded by a place, and therefore circumscribed. For when the angel went to Nazareth and said to the Virgin, "Rejoice!"[42] he was not elsewhere. But the Word of the Father, conceived in the womb of the Theotokos, was present there and at the same time was above all things. For this reason He is uncircumscribable and boundless as God, although as man, because He was born from the Virgin, He is circumscribed.

48. If He who "was in the form of God" is not circumscribed in respect to the "form of a servant" which He took,[43] this form would be not other than the divine form (if indeed uncircumscribability characterizes the divine form). But if the form of a servant is different and shares our essence, how did He take the form of our essence without taking also its property? Therefore Christ is circumscribed, since we also are circumscribed, whose form He took.

49. If the fact that Christ is circumscribed as man

[41]I Cor. 15.40. [42]Luke 1.28. [43]Phil. 2.6-7.

detracts from the fact that as God He is not circumscribed: then the things which He appears doing and saying as man must also detract from the things which He is revealed teaching and working marvelously as God. But if in this case the one does not detract from the other, as each remains within its own limits in Christ who is from both, then in the former case also circumscription will not eliminate uncircumscribability.

50. In conversation with some Jews, the Savior says, "Before Abraham was, I am."[44] The evangelist Matthew, however, says, "The book of the genealogy of Jesus Christ, the son of David, the son of Abraham."[45] How can He who was before Abraham be the son of Abraham? Is it not obvious that we should understand that the one statement is appropriate to divinity, the other to humanity? We should think the same about circumscription and uncircumscribability, that one will not detract from the other in the single Christ who is acknowledged to be from both.

51. If every mediator mediates between two persons opposed to each other, distributing the rights of each side fairly in himself: then Christ, who is the mediator between God and man, and who (so to speak) combines the extremes into a union of natures by a just judgment, must be uncircumscribable in spirit but circumscribed in body. Otherwise, if He favored the one, namely uncircumscribability, and did not maintain the other, namely circumscription, unharmed, He would fail to be a just mediator.

52. If Christ died as man and incurred no reproach as God, it would be no disgrace to Him either to be circumscribed in a human way. But if circumscription is humiliating, then mortality is much more so.

[44]John 8.58. [45]Matt. 1.1.

53. *An objection as from the iconoclasts:* "Circum-scribing Christ is somehow inconsistent with and forbidden by the divinely inspired Scripture. For it says, 'The Lord spoke to you' on the mountain 'out of the midst of the fire; you heard the sound of words, but saw no likeness; there was only a voice.'[46] Therefore erecting the likeness of Christ conflicts with the divine prohibitions."

Answer: Those who say these things are making them-selves deaf by not recognizing why holy Scripture prohibits a likeness or any kind of representation used as an idol: because it is speaking about the divine nature (for the God-head is measureless and formless, and has no relationship at all to any likeness) and not about the Word which has received an essence in our form. For if the evangelist says, "And as He was praying, the appearance of His counte-nance was altered, and His raiment became dazzling white,"[47] we can see that the invisible one had an appearance or likeness, the formless one had a form, and the measure-less one came within a measure. And since He had a countenance circumscribed by certain properties, therefore Christ is circumscribed in respect to His bodily appearance, just as He is uncircumscribable in respect to His invisible essence.

54. If, whatever kind of being she is who gives birth, that which is born must be the same kind of being: since the mother of Christ is circumscribed, then Christ also is circumscribed, as her son, although He is God by nature. But if He is not circumscribed, then He does not have the same essence as His mother. Hence it would follow that His mother is not His mother—which is absurd.

55. *An objection as from the iconoclasts:* "Everyone will understand that the depiction of Christ is an invention

[46]Deut. 4.12. [47]Luke 9.29.

of an idolatrous mentality. For the apostle says somewhere,
'And they exchanged the glory of the immortal God for
the likeness of the image of mortal man . . . and they ven-
erated and worshipped the creature rather than the
Creator.' "[48]

Answer: Truly, to speak like the apostle, since the
iconoclasts have fallen into a disreputable state of mind,
"their senseless minds were darkened. Claiming to be wise,
they became fools,"[49] "not understanding either what they
are saying or the things about which they make assertions."[50]
For if it is to prohibit the depiction of Christ that the
apostle says, "They exchanged the glory of the immortal
God for the likeness of the image of mortal man," he has
not yet confessed that God became like men. How can he
say elsewhere, "Who, though He was in the form of God,
did not count equality with God a thing to be grasped, but
emptied Himself, taking the form of a servant, being born
in the likeness of men, and being found in human form.
He humbled Himself and became obedient unto death, even
the death on a cross"?[51] So he contradicts himself, in one
place denying that God has become like men, but in another
place affirming that He has been born in the likeness of
men. But enough of this silliness! The first passage is ap-
plied to the idolators, who truly "exchanged the glory of
the immortal God for the likeness of the image of mortal
man or birds or animals or reptiles . . . and exchanged the
truth about God for a lie and venerated and worshipped
the creature rather than the Creator."[52] The second is
addressed to the faithful, who believe that the Word of
God the Father, "though He was in the form of God,"
became like them, not by being equal to God, but by empty-
ing Himself, "taking the form of a servant . . . and being

found in human form."[53] All these are properties of circumscription.

56. If we "are the body of Christ and individually members of it,"[54] and Christ is our head, then the head must be circumscribed like the members. If He is uncircumscribable, we have ceased to be members of Christ, since we are subject to the circumscription of form. Is this not the height of foolishness?

57. If the Savior says that He is the vine and we are the branches,[55] obviously the branches are not different in kind from the vine. But if this is true, since the branches are circumscribed, how can the vine not be circumscribed? For the vine is recognized by its branches.

58. Things which are different in kind and nature cannot have the same property. No one would say that fire flows downward, but water upward; but as they differ in the principle of their essence, so also they differ in the mode of their properties. Since Christ is from natures which are different in kind and not consubstantial, namely divinity and humanity, He must be recognized also in two properties, being both uncircumscribed and circumscribed. For if one property is eliminated, then the essence which is characterized by that property is also eliminated.

B. Because Christ is circumscribed, He has an artificial image, in which He is contemplated, as it is also in Him.

1. Whatever is artificial imitates something natural; for nothing would be called artificial if it were not preceded by something natural. Therefore there is an artificial image

[53]Phil. 2.6-8. [54]I Cor. 12.27. [55]John 15.5.

of Christ, as He is the natural image of the mother who bore Him. But if the latter is true and the former false, He would not be the natural image of His mother, if He did not have an artificial image as she does—which is absurd.[56]

2. Every image has a relation to its archetype; the natural image has a natural relation, while the artificial image has an artificial relation. The natural image is identical both in essence and in likeness with that of which it bears the imprint: thus Christ is identical with His Father in respect to divinity, but identical with His mother in respect to humanity. The artificial image is the same as its archetype in likeness, but different in essence, like Christ and His icon. Therefore there is an artificial image of Christ, to whom the image has its relation.[57]

3. *An objection as from the iconoclasts:* "If Christ has an artificial image insofar as He is the natural image of His mother, then in order that the image should not depart at all from similarity with Him, He would also have an artificial image insofar as He is the image of the invisible Father. But if this is so, the Godhead is not exempt from circumscription—which is heretical to say."

Answer: In their great foolishness the iconoclasts mix things which cannot be mixed and do not understand how to attribute to each origin its own properties, because of which Christ is both uncircumscribable and circumscribed. In respect to His coming forth from the uncircumscribable Father, since He is uncircumscribable, He would not have an artificial image: with what likeness can the Godhead

[56]The meaning seems to be: if Mary has an artificial image and Christ does not, then He is not like her (not her natural image).

[57]If the artificial image had to have the same essence as Christ (as the iconoclasts claimed), it would have to be divine, which is impossible.

be compared, for which the divine Scripture utterly forbids any representation? But in respect to His birth from a circumscribed mother, with good reason He has an image, just as His mother's image is expressed in Him. But if He should not have an image, then He would not be from a circumscribed mother, and is of only one origin, namely the paternal—which destroys the divine economy.

4. If what is shown in the image refers to the prototype, and if whenever there is a prototype there must also be an image (in accordance with the Lord's words, "Whose is this image and inscription?" and his following words, to the questioners, "Render to Caesar the things that are Caesar's, and to God the things that are God's"[58]): then Christ, since He became like us, has an artificial image, which refers to Him by a relation of likeness. But if He does not have an artificial image, then He is not what is called the Christ. But Christ is, and is called, truth itself. Therefore He has an image, and its reference of veneration which passes over to Him is never cut off by a division of glory.[59]

5. The fact that man is made in the image and likeness of God[60] shows that the work of iconography is a divine action. But since an image can be copied from an image, inasmuch as Christ is man, though also God, He can be portrayed in an image, not in spirit but in body. But if He is portrayed in one of the two, then obviously He has an image exactly resembling Him which reveals the shared likeness.

6. If Adam the first man is circumscribed by His

[58]Matt. 22.20, 21.
[59]Basil, *On the Holy Spirit* 18.45 (PG 32.149).
[60]Gen. 1.26.

form, then also Christ the second Adam, as He is both
God and man, can equally be portrayed in His bodily form.
If, moreover, "As was the man of dust, so are those who
are of the dust; and as is the man of heaven, so are those
who are of heaven,"[61] and if we who are of heaven can be
portrayed, then Christ, as He is the originator of the salva-
tion of all, is also the original of His own image.

7. If God needs no help, and is not subject to any
suffering, how can the apostle say about Him, "In the days
of His flesh, He offered up prayers and supplications, with
loud cries and tears, to Him who was able to save Him
from death, and He was heard for His godly fear. Although
He was a son, He learned obedience through what He suf-
fered"?[62] Is it not obvious that the fleshless one who as-
sumed flesh is exempt from suffering and yet able to suffer,
in need of nothing and yet needy, just as He is both un-
circumscribable and circumscribed? But if He is circum-
scribed, then He has an image exactly resembling Him
which reveals the shared likeness.

C. *There is one indivisible veneration of Christ and
His image.*

1. *An objection as from the iconoclasts:* "If every
thing which is made in the likeness of something else in-
evitably falls short of equality with its prototype, then
obviously Christ is not the same as His portrait in regard
to veneration. And if these differ, the veneration which you
introduce differs also. Therefore it produces an idolatrous
worship."

Answer: The prototype is not essentially in the image.
If it were, the image would be called prototype, as con-

[61]I Cor. 15.48. [62]Heb. 5.7-8.

versely the prototype would be called image. This is not admissable, because the nature of each has its own definition. Rather, the prototype is in the image by the similarity of hypostasis, which does not have a different principle of definition for the prototype and for the image. Therefore we do not understand that the image lacks equality with the prototype and has an inferior glory in respect to similarity, but in respect to its different essence. The essence of the image is not of a nature to be venerated, although the one who is portrayed appears in it for veneration. Therefore there is no introduction of a different kind of veneration, but the image has one and the same veneration with the prototype, in accordance with the identity of likeness.

2. It is not the essence of the image which we venerate, but the form of the prototype which is stamped upon it, since the essence of the image is not venerable. Neither is it the material which is venerated, but the prototype is venerated together with the form and not the essence of the image. But if the image is venerated, it has one veneration with the prototype, just as they have the same likeness. Therefore, when we venerate the image, we do not introduce another kind of veneration different from the veneration of the prototype.

3. Those things which do not have the same forms have different kinds of veneration; but those which have the same form also have one kind of veneration. The image has one form with its prototype: therefore they have one veneration.

4. Everything which is unequal is different from that which is equal; and everything which is inferior in glory is something other than that which is superior. They are two, and not one. But where there is equality, inequality is

eliminated; and where there is identity, inferiority and
superiority are eliminated. Now the image of the emperor
is also called emperor, and there are not two emperors,
nor is his power divided, nor his glory fragmented.[63] There-
fore there is one glory, and no different kind of veneration
is introduced, when the image of Christ is venerated for
Christ's sake, although obviously it has a lower and inferior
glory in respect to the principle of its essence.

5. Even if we grant that the image does not have the
same form as the prototype because of insufficient artistic
skill, still our argument would not be invalid. For venera-
tion is given to the image not insofar as it falls short of
similarity, but insofar as it resembles its prototype. In this
degree the image has the same form as the prototype; and
the objects of veneration are not two, but one and the same,
the prototype in the image. The same is true of the symbol
of the cross in relation to the life-giving cross itself. In this
case also the depiction does not have exactly the same form
as the archetype, in length and width or any other relation-
ship, because it is represented differently. Crosses can be
seen small and large, wider and narrower, with blunt or
sharp ends, with or without inscription. And I have not
yet mentioned the varieties and prominence of chain-
patterns or the diversity of workmanship. Nevertheless, in
spite of such great differences, there is one veneration of
the symbol and the prototype; so evidently the same like-
ness is recognized in both.

6. If the life-giving cross is venerated in its symbol,
yet there are not two kinds of veneration, because the
essence of the symbol is not venerated separately: then
necessarily there are not two kinds of veneration when
Christ is venerated in His image, because the essence of

[63]Basil, *On the Holy Spirit* 18.45 (PG 32.149).

the image is not venerated. Rather, the veneration of Christ Himself and of Christ in the image is one and the same.

7. If the fact that the Son differs in some respect from the Father (He differs only in the property of sonship) does not prevent Him from having the same essence and veneration as the Father, then the fact that the image differs in some respect from the prototype (it differs in respect to the principle of its essence) will not prevent it from having the same likeness and veneration as its prototype. Just as Christ is distinguished from the Father by His hypostasis, so He is distinguished from His image by His essence.

8. If the image is differently venerated from its prototype, how is the prototype seen in the image, and the image in the prototype? Obviously we do not contemplate Peter's form, for example, in Paul; nor conversely does anyone see Paul's form in Peter's form. For like appears in like; but things which differ from each other in likeness could never appear in each other. Rather, the image of Peter appears in Peter, just as Peter appears in his own image. Therefore the image of Christ is not differently venerated from Christ Himself, but is venerated in the same way, as it has an exact resemblance and likeness to Him.

9. *An objection as from the iconoclasts:* "If God alone deserves veneration both from us and from the angels, how can there be a single veneration of the image with Christ, if indeed we confess that the one is venerated by relationship, but the other by nature? Therefore there are two kinds of veneration for the one Christ, because of the veneration of the image. This is impious."

Answer: If, because we offer veneration to God alone, we ought not venerate the image of Christ, on the grounds that two kinds of veneration are introduced instead of the one worship, in accordance with the duality of the image

and the prototype: then the veneration of the Father and the Son will also be dual, because of the duality of their hypostases. But if this is impious to say, for obviously the veneration is one and the same in accordance with the unity of nature, then the veneration of Christ and His image is also one, in accordance with the unity of hypostatic likeness, regardless of the diversity of natures.

10. We speak of relation inasmuch as the copy is in the prototype; one is not separated from the other because of this, except by the difference of essence. Therefore, since the image of Christ is said to have Christ's form in its delineation, it will have one veneration with Christ, and not a different veneration.

11. *A proposition as from the iconoclasts:* "How could the identity of veneration be preserved in the case of Christ and His image, if indeed Christ is naturally venerable, but the image is arbitrarily venerable? For we certainly must say that a natural quality cannot change at all. But if this is so, nothing prevents the image from being naturally venerable, and Christ arbitrarily venerable. So everything is confused."

Answer: How could the identity of veneration not be preserved, gentlemen, in the case of Christ and His image, if indeed the image is the likeness of Christ and reveals Christ in itself? Surely it is well known and agreed by everyone that no one could see the countenance of one, let us say Luke, in the countenance of another, let us say Thomas. For likeness is shown in things which are exactly similar, not in things which differ from each other in their characteristic property. If, therefore, this is true, and he who has seen the image of Christ has seen Christ in it, we certainly must say that as the image of Christ has the same likeness, so also it has the same veneration as Christ.

12. That which is similar in some degree to another thing shares its veneration to the degree in which it is similar. That which is similar in all ways shares the veneration fully. The Son is similar to the Father in all ways, as He has the same essence; therefore He has the same veneration. The image of Christ is similar to Him only in the likeness of His hypostasis; therefore it could share His veneration only in this respect.

13. If he who has seen the image sees in it the likeness of the prototype, then he who venerates the image necessarily venerates in it the appearance of the prototype. But since the likeness is one, the veneration of both must also be one.

14. *An objection as from the iconoclasts:* "If the image which is modeled on Christ shares His veneration, how can He Himself say, 'My glory I give to no other'?[64] Therefore the image does not share the veneration. But if it does not share, then one must admit that it is venerated idolatrously, as a second kind of veneration is introduced for it."

Answer: The image of Christ is nothing else but Christ, except obviously for the difference of essence, as we have repeatedly proved. It follows that the veneration of the image is veneration of Christ. The material of the image is not venerated at all, but only Christ who has His likeness in it. Those things which have a single likeness obviously also have a single veneration. Therefore Christ does not give His glory to another in His own image, in which rather He obtains the glory for Himself, since the material is something other than the likeness. Doubtless the same form is in all the representations though they are made with different materials. The form would not remain unchanged

[64]Is. 42.8.

in the different materials if it were not for the fact that it shares nothing with them, but is conceptually distinguished from the materials in which it occurs.

15. *An objection as from the iconoclasts:* "If 'God is spirit, and those who venerate Him must venerate in spirit and in truth,'[65] how do you avoid convicting yourselves of idolatry when you say that Christ (since He is God) is venerated in an image as well as in spirit?"

Answer: Who will not be amazed at the insanity of the iconoclasts, who do not recognize how different the doctrine of the economy is from that of theology? The saying about veneration in spirit and in truth belongs to theology. For since God the Father is spirit, He is understood to be venerated in the Holy Spirit and in the Truth, which is His only-begotten Son.[66] But the veneration of Christ in the image belongs to the discussion of the economy. Although Christ is spirit because He is God, yet He is also flesh because He is man. Even though His bodily image is represented in matter, yet it is inseparable from Christ, like the shadow of a body. We do not venerate the material of the image, but Christ who is portrayed in it: Christ together with whom we venerate the Father and the Holy Spirit.

D. Since Christ is the prototype of His own image, He has one likeness as He has one veneration with it.

1. The prototype and the image are one in hypostatic likeness, but two in nature: one entity is not split into two likenesses, so as thereafter to have no participation or relation with each other; nor is one and the same entity called by two names, so that at one time the prototype would be called image, and at another time the image

[65]John 4.24. [66]John 14.6.

would be called prototype. For the prototype would always be called prototype, just as the image would be called image, one never changing into the other. Although this is the fact, and although the number is dual, both have one likeness, and one name in accordance with the likeness: as for example the emperor's image is also called emperor, yet there are not two emperors.[67] But if this is so, then also the image of Christ has one veneration with Christ its prototype.

2. *An objection as from the iconoclasts:* "If Christ, having the relation of prototype to His image, is said to exist naturally, but the image to exist arbitrarily, how can the natural exist simultaneously with the arbitrary? For it is not true that as soon as Christ was seen His delineated image came along with Him. Therefore, since these are not simultaneous, they do not have one veneration, because they are separated by a certain lapse of time, in which the image was produced after Christ."

Answer: If every body is inseparably followed by its own shadow, and no one in his right mind could say that a body is shadowless, but rather we can see in the body the shadow which follows, and in the shadow the body which precedes: thus no one could say that Christ is image-less, if indeed He has a body with its characteristic form, but rather we can see in Christ His image existing by implication and in the image Christ plainly visible as its prototype. From the simultaneous existence of both, it follows that when Christ is seen, then His image is also potentially seen, and consequently is transferred by imprint into any material whatever.

3. Even if the natural is not simultaneous with the arbitrary, as Christ with His image, nevertheless by its po-

[67]Basil, *On the Holy Spirit* 18.45 (PG 32.149).

tential existence even before its artistic production we can always see the image in Christ; just as, for example, we can see the shadow always potentially accompanying the body, even if it is not given form by the radiation of light. In this manner it is not unreasonable to reckon Christ and His image among things which are simultaneous.

4. The prototype and the image belong to the category of related things, like the double and the half. For the prototype always implies the image of which it is the prototype, and the double always implies the half in relation to which it is called double. For there would not be a prototype if there were no image; there would not even be any double, if some half were not understood. But since these things exist simultaneously, they are understood and subsist together. Therefore, since no time intervenes between them, the one does not have a different veneration from the other, but both have one and the same.

5. The prototype and the image have their being, as it were, in each other. With the removal of one the other is removed, just as when the double is removed the half is removed along with it. If, therefore, Christ cannot exist unless His image exists in potential, and if, before the image is produced artistically, it subsists always in the prototype: then the veneration of Christ is destroyed by anyone who does not admit that His image is also venerated in Him.

6. *An objection as from the iconoclasts:* "That which is similar in some respect is dissimilar in another respect; as the image is similar to the prototype in likeness, but dissimilar in nature. Therefore the image is not wholly what the prototype is. But since this is so, both do not have the same whole veneration. If the veneration is not whole, it is futile to say that both have one veneration."

Answer: Insofar as the image resembles the prototype, it shares its whole veneration on the basis of resemblance, not bringing into veneration the material in which it appears; for this is the nature of the image, to be identified according to likeness with the prototype, but to differ according to the principle of its essence. For this reason the image has homonymy with the prototype. But if it were wholly similar, what we have said has collapsed, and the image is simply the prototype. However, it resembles the prototype in its whole likeness, but not in its nature. Therefore both have one whole veneration on the basis of resemblance.

7. Although the Son is like the Father in essence, yet that which is begotten is not like the unbegotten, nor is that which proceeds. These properties which are contemplated in the divine nature are distinguished from what they share with one another. But the divinity is one in the three persons, as the veneration is one; and because of the identity of nature the veneration is not at all made unequal by the difference of properties. The same is true for the image of the prototype. Although in respect to the difference of essence, both do not have one veneration (because the nature of the image is not venerated, even though the one who is portrayed appears in it); nevertheless in respect to the identity of the hypostatic likeness, the veneration is made identical in accordance with the one complete similarity in both. Likewise, in the case of the symbol of the cross and the life-giving cross itself, the veneration of the symbol is not diminished in comparison with the life-giving cross, but rather equalized by its complete likeness with the prototype.

8. *An objection as from the iconoclasts:* "If the image is in Christ as prototype even before it is transferred artistically into some kind of material, it would be super-

fluous to depict the image, which is sufficiently seen and venerated in Him."

Answer: It is true that, even before the image of Christ is transferred by artistic means, it is present in Him as prototype. For that which is not portrayed in any way is not a man but some kind of abortion. However, it is not admissible to call something a prototype if it does not have its image transferred into some material. Therefore, since we confess that Christ has the relation of prototype, like any other individual, He undoubtedly must have an image transferred from His form and shaped in some material. Otherwise He would lose His humanity, if He were not seen and venerated through the production of the image.

9. A seal is one thing, and its imprint is another. Nevertheless, even before the impression is made, the imprint is in the seal. There could not be an effective seal which was not impressed on some material. Therefore Christ also, unless He appears in an artificial image, is in this respect idle and ineffective. This is absurd even to consider.

10. If he who looks at the seal and its imprint sees a similar and unchanged form in both, then the imprint exists in the seal even before the impression is made. The seal shows its desire for honor when it makes itself available for impression in many different materials. In the same way, although we believe that Christ's own image is in Him as He has human form, nevertheless when we see His image materially depicted in different ways, we praise His greatness more magnificently. For the failure to go forth into a material imprint eliminates His existence in human form.

11. For the archetype the image and the image for the archetype exists, appears, and is venerated; not that

the essence is identified, but that the likeness is unified. In respect to the likeness, the unified veneration belongs to both, but is not divided by the difference of natures.

12. If the shadow cannot be separated from the body, but always subsists along with it, even if it does not appear, in the same way Christ's own image cannot be separated from Him. As the shadow becomes clearer with the radiation of the sun, so also Christ's image becomes more conspicuous to all when it appears by imprinting itself in materials.

13. *An objection as from the iconoclasts:* "Now that our Savior is in the heavens, we ought not to erect His image: for the holy apostle says, 'We walk by faith, not by appearance.' "[68]

Answer: "Appearance" (εἶδος) is used to mean "species" as distinguished from genus: for example, man in general; "appearance" is also used for the form of each individual, by which we differ one from another. About these the apostle does not speak here. We must understand that he uses "appearance" meaning the sight of things to come which surpasses the present figures. For when he says, "We walk by faith, not by appearance," he adds, "We are of good courage, and we would rather be away from the body and at home with the Lord."[69] And elsewhere he says, "For now we see in a mirror dimly, but then face to face. Now I know in part; then I shall understand fully, even as I have been fully understood. So faith, hope, and love abide."[70] Thus he says that we walk by such a faith that we see as if in a mirror face to face unerringly the truth of the things to come. Besides, for proof that his object was not to prohibit the depiction of Christ's

[68]2 Cor. 5.7. [69]2 Cor. 5.7-8. [70]I Cor. 13.12-13.

bodily form, even after His ascension, listen to what he
says elsewhere: "O foolish Galatians! Who has bewitched
you, before whose eyes Jesus Christ was publicly portrayed
as crucified?"[71] If this is how we believe, so as to behold
Christ Himself crucified, then with good reason we do not
err in depicting Him at all times. For if that which is seen
mentally while absent should not also be seen perceptibly
through depiction, even the mental vision would be lost.

[71]Gal. 3.1.

SELECT BIBLIOGRAPHY

Every, George, S.S.M., *The Byzantine Patriarchate 451-1204,* London: SPCK, 1962. Chapter 7, "Iconodulia," and Chapter 8, "Iconoclasm."

Gardner, Alice, *Theodore of Studium: His Life and Times,* London: Edward Arnold, 1905.

Meyendorff, John, *Byzantine Theology: Historical Trends and Doctrinal Themes,* New York: Fordham University Press, 1974. Chapter 3, "The Iconoclastic Crisis," and Chapter 4, "Monks and Humanists."

Meyendorff, John, *Christ in Eastern Christian Thought,* Washington and Cleveland: Corpus Books, 1969. Chapter 9, "Vision of the Invisible: the Iconoclastic Crisis."

Ouspensky, Leonid, *Theology of the Icon,* Crestwood, N.Y.: St. Vladimir's Seminary Press, 1978. Chapter 8, "The Iconoclastic Period: an Abridged History"; Chapter 9, "The Iconoclastic Teaching and the Orthodox Response."

Pelikan, Jaroslav, *The Christian Tradition: A History of the Development of Doctrine II: The Spirit of Eastern Christendom (600-1700),* Chicago: University of Chicago Press, 1974. Chapter 3, "Images of the Invisible."

POPULAR PATRISTICS SERIES

ST VLADIMIR'S SEMINARY PRESS
1-800-204-2665 • www.svspress.com